renaissance

MANFRED WUNDRAM
INGO F. WALTHER (ED.)

TASCHEN

HONGKONG KÖLN LONDON LOS ANGELES MADRID PARIS TOKYO

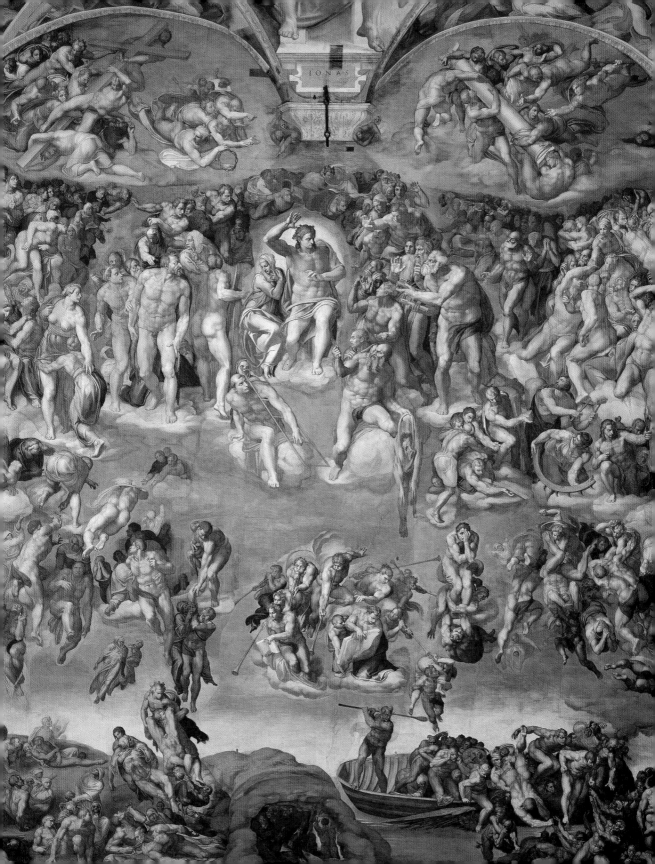

Contents

european painting in the 15th and 16th centuries

During the Early Renaissance, painting rose to a position of primacy amongst its fellow disciplines for the first time in the history of Western art. A new relationship was born between the work of art and the spectator: the painting no longer sought merely to fulfil a function, but issued its own challenge to the person before it. Amongst the great innovations of this new era were the exploration of perspective and proportion, a new understanding of portraiture as the likeness of an individual, and the beginnings of landscape painting. Artists increasingly trod a path away from superficial "naturalness" in their works and towards a more profound understanding of the natural world, a trend seen in Italy in Masaccio, Uccello, Piero della Francesca, Botticelli and Mantegna and in Germany in Multscher and Witz. In the Netherlands, meanwhile, panel painting flowered at the hands of the van Eyck brothers, Rogier van der Weyden, Hugo van der Goes, Memling, and in the mysterious spectral world of Hieronymus Bosch. In Venice in the late 15th century, Antonello da Messina and Giovanni Bellini in particular spearheaded a revolution in painting whose impact would reverberate beyond the High Renaissance and into the 16th century.

In the painting of the Renaissance, Western art reached its absolute zenith. The new intellectual horizons opened up by the natural sciences and the great voyages of discovery, together with the religious tensions of the era and its political and social unrest − all were reflected in painting. The real and the ideal, the secular and the sacred, ecstatic absorption and cool scepticism flourished side by side. It was Leonardo da Vinci who took the decisive step by abandoning the balance which had previously been maintained between colour and line, and choosing instead to modulate his contours by means of colour. Raphael and Michelangelo followed his example and created forms which would set the standard for the whole of Europe. At almost the same time, Giorgione, Titian, Tintoretto and Veronese in Venice were crafting a new artistic vision in which man and nature were combined into a single unity.

In Germany, painting saw an unprecedented flowering at the hands of Dürer and Grünewald, Altdorfer, Holbein and Lucas Cranach. While in the Netherlands the creative genius of Pieter Brueghel outshone all else, the epoch found its final voice in the religious visions of El Greco.

The major stylistic epochs into which we like to divide Western art − Pre-Romanesque, Romanesque, Gothic, Renaissance and Baroque − are no more than pointers offering us a primitive means of orientation. They are approximations within a development which, while often driven by artistic innovation, might equally well imply the revival of earlier design principles; a development characterized less by clear breaks than by ongoing evolution. And even within this evolution, phase displacements must be taken into account which challenge the validity of any single definition of the epoch.

There can be few other epochs in our European past which so stubbornly refuse to fit under a generalized heading than the 15th century. While in Italy around 1400 the dawn of the Early Renaissance was heralding a new age in art − the competition for the two bronze doors for the Baptistery in Florence in 1401 is seen as a pivotal event in this development − the countries north of the Alps were experiencing an unparalleled flowering of what is termed the Late Gothic. The Renaissance is generally perceived to have arrived here only one hundred years later, in particular in the wake of the two trips which Albrecht Dürer (1471−1528) made to Italy in 1496 and 1506/07.

1413 — Filippo Brunelleschi discovers central perspective. gives a boost to the Papal State and the power of the popes.

1417 — The ending of the Great Schism by the Council of Constance
1420 — Venice re-establishes her dominance over Dalmatia.

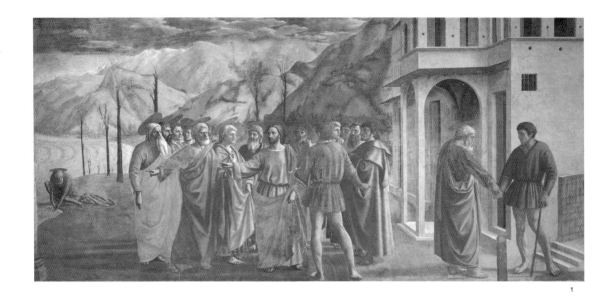

1

It has for a long time been clear, however, that this polarization into Early Renaissance and Late Gothic frequently fails to describe the forms adopted by art in the 15th century. The introduction of the terms "Early German" and "Early Netherlandish" for painting north of the Alps in order to distinguish it from Gothic art simply postponed the problem. Similarly, the term "Sondergotik" (special Gothic) coined by Kurt Gerstenberg in 1917 to describe 15th-century German architecture is merely a means of demarcating the latter from the Late Gothic, without clearly identifying its character. Is it possible, then, to find other categories for the art – and specifically the painting – of the century from 1400 to 1500 which more aptly describe its different and common traits?

The Advent of the Early Renaissance

Let us turn first to Italy, seemingly the most "progressive" region of Europe in the early 15th century. Florence, a centre of moderate political but great economic importance, was emerging as the cradle of a new development in art which, in the eyes of the historians of the 19th century and in particular Jacob Burckhardt (1818–1897), was comparable only to Athens in the 5th century BC. At the chronological forefront of this new trend stood a number of outstanding sculptors, amongst them Lorenzo Ghiberti (1378–1455), Nanni di Banco (c. 1375–1421) and Donatello (c. 1382/86–1466). They replaced the drapery-clad statuary of the Middle Ages with the figure sculpture of the Renaissance, developed out of the organic structure of the human body, and created a style of relief which permitted them to carve highly naturalistic multi-figural scenes with a spatial depth previously un-

known. A similar development took place in architecture around 1420, in the early works of the architect Filippo Brunelleschi (1377–1446) – the Foundling Hospital, the Old Sacristy at San Lorenzo and the church of San Lorenzo itself. Here, Gothic architecture was replaced by a new style whose dimensions were reduced to a humanly comprehensible scale and which adopted individual elements from the architecture of Ancient Rome. Finally, starting in 1424 and within a rapid space of just five years, there followed the works of the painter Masaccio (1401–1428), whose portrayal of perspective and anatomy pointed the way forward for the entire century.

Classical antiquity thereby served as a source of inspiration to all three branches of art. The statues of Donatello and Nanni di Banco revived the contrapposto figure sculpture, whereby the figure stands poised with most of its weight on one leg and with the other leg relaxed. Such references to the past were made doubly clear in other details, such as the reappearance of the Roman toga. This revival of late Antique and early Christian forms was most apparent of all in architecture. Meanwhile, as Emil Maurer has shown in the case of the fresco of the *Tribute Money* (ill. p. 7), Masaccio was probably familiar with the early Christian mosaics in San Paolo fuori le mura in Rome.

Is it therefore true that, as art-historical tradition has long maintained, the Florentine Early Renaissance represented a revival of sculpture, architecture and painting in the spirit of classical antiquity? The body of art surviving from the period before 1400 quite clearly proves the opposite. In Tuscan architecture of the late 11th and early 12th centuries, which Burckhardt has described as "Proto-Renaissance", we find the same classicizing decorative forms and the same harmoniously balanced organization of interiors and walls employed by Brunelleschi in his early works. The Baptistery and the façade of San

1429 — Joan of Arc succeeds in having Charles VII crowned in Rheims as king of the whole of France.
1431 — Cosimo de Medici becomes ruler of Florence and has the Palazzo Medici and the cathedral dome built.

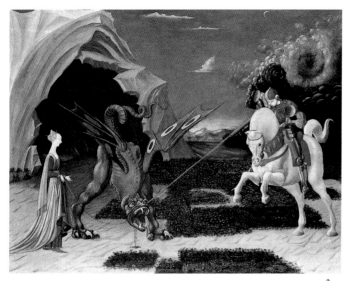

1. MASACCIO
<u>The Tribute Money</u>
1426/27
Fresco, 255 x 598 cm
Florence, Santa Maria del Carmine, Brancacci Chapel

2. PAOLO UCCELLO
<u>St George and the Dragon</u>
c. 1456, Tempera on canvas, 57 x 74 cm
London, National Gallery

3. ANDREA DEL CASTAGNO
<u>Farinata degli Uberti</u> from the series of
<u>Uomini famosi</u> in the Villa Pandolfini, Legnaia
c. 1450, Fresco, 250 x 154 cm
Florence, Galleria degli Uffizi

4. ANTONELLO DA MESSINA
<u>The Virgin of the Annunciation</u>
c. 1475, Oil on wood, 45 x 34.5 cm
Palermo, Galleria Nazionale della Sicilia

2

Miniato in Florence are the most important surviving examples of this Renaissance movement, which can also be seen less explicitly in the Tuscan Gothic. The heritage of antiquity thus runs throughout like an unbroken thread, more or less close to the surface.

A similar situation applied to sculpture. Here, too, the important influence of late Antique and early Christian models was never questioned. Nicola Pisano (c. 1220 – before 1287), his son Giovanni (c. 1245 – after 1314) and his pupil Arnolfo di Cambio (c. 1254 – c. 1302) indeed revived sculpture in the spirit of classical antiquity; both in their own creations and in other outstanding works by Florentine cathedral stonemasons dating from the latter decades of the 14th century, classical models were copied on a scale which, after 1400, was found only in exceptional instances. Without wishing to dispute the fact that this exploration of antiquity was continued by the Early Renaissance, it may be said that classical antiquity was not the decisive force which propelled Western art across the threshhold from the Middle Ages into the Renaissance.

This conclusion is reinforced by the origins of the term "Renaissance". In his Lives of the Artists, first published in 1550 and subsequently reprinted in an expanded edition in 1568, Vasari was the first to speak of the "rinascità", the rebirth of art. By that, however, he did not mean a rediscovery of antiquity, but rather the rebirth of "good art", something in his eyes synonymous with a renunciation of the art of the Middle Ages, with its formal vocabulary abstracted from nature, and in particular of the severe linear style derived from Byzantine art, which he termed the "maniera greca". For Vasari, an – if not the – decisive chapter in Italian art began with the painting of around 1300, represented above all by Giotto (1266?–1337). More recent research, not least in neighbouring disciplines within the humanities, has itself

pondered the question of whether the transition from the 13th to the 14th century was not indeed more profound than that from the 14th to the 15th. Thus the "rediscovery of the world and of man" postulated by Burckhardt as the prime mover of the Early Renaissance had its roots in the 14th century. Amongst Giotto's successors, and in particular the great Sienese painters Simone Martini (c. 1280/85–1344), Ambrogio (c. 1290 – c. 1348) and Pietro Lorenzetti (c. 1280/90–1348?), this exploration of the phenomena of here-and-now reality was pursued to an astonishing degree. The focus in Giotto's era upon the large, summarized form was thereby both enriched and at the same time replaced by the precise study of details.

We can therefore state the following: firstly, it was not classical antiquity but the entry into art of the real world of human experience – the reproduction of figure, space and landscape – which laid the foundations for the Early Renaissance. Secondly, the years around 1400 represent a major stage, but not an abrupt break in this development.

What is it then which entitles us to see in the 15th century a new chapter in Western culture? Vasari once again provides a clue to the answer. While in Giotto he praised the naturalness of the painter's style, in the leading artists of the Early Renaissance he admired the perfect imitation of nature. For him, Giotto and Masaccio represented the first and second stages in the rinascità; in terms of fidelity to nature, Masaccio was a Giotto on a higher level, so to speak. To see things in this light, however, is an inadmissible simplification of the truth. It is true that Leonardo da Vinci (1452–1519) also praised Masaccio for his faithful study of nature; offering an important insight into the epoch, however, he also added that nature should not simply be copied, but shown in all its perfection. "Painting preserves that harmony of corresponding parts which nature, with all its powers, is

1435 — In his work *De pictura* Leon Battista Alberti puts painting on a mathematical-scientific basis of geometry and central perspective.

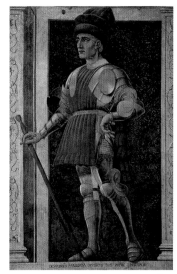

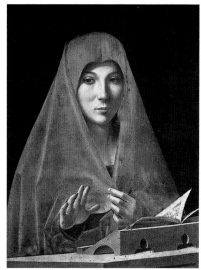

"Due to the imperfection of the times, colantonio did not archieve the perfection in his drawings of antiquities attained by his pupil Antonello da Messina …"

Pietro Summonte

unable to maintain. It keeps alive the image of a divine beauty whose natural model is soon destroyed by time and death."

It is thus the search for the ideal norms underlying the outer face of nature which distinguishes the 15th from the 14th century. The inner kinship between classical antiquity and the Early Renaissance lies in this interpenetration of the real and the ideal, and not in the sphere of outer similarity. The fact that artists nevertheless looked back to their classical heritage was conditioned by their search for "natural" forms – in accordance with the maxim of Denis Diderot (1713–1784): "Il faut étudier l'antiquité pour voir la nature" (one must study antiquity to see nature). Cause and effect are here stood on their head: it was not the wish to copy antiquity that led artists to adopt naturalistic forms, but the desire to reproduce natural forms that opened their eyes to antiquity.

There is a second, no less important factor distinguishing the 15th from the 14th century. While the portrayal of space and the human figure during the 14th century was based largely on pragmatic values, from about 1420 it began to assume a mathematical dimension. Perspective and the theory of proportion, especially, were discussed and investigated from a scientific point of view. This was the consequence of a philosophical awareness arising from man's new conception of his status within Creation. The new value attached to the individual, unknown in the Middle Ages, was reflected in the fine arts in the emergence of a new genre: portraiture in the modern sense of the word, i.e. the picture of a unique, unmistakable personality. The portrayal of donors changed for the same reason; having been accorded only diminutive stature in medieval art in line with their perceived insignificance, they now assumed the same size as saints and other figures from religious history.

A comparison of Florence with the art-producing regions of northern Italy, and in particular Lombardy and Venice, spotlights a number of positively contradictory phenomena. Lombardy and Venice were, alongside Tuscany, the most important centres of Italian art; following the return of the papacy from Avignon (1376) and the Great Schism (1378–1417) which followed, Rome had been relegated for the time being to artistic obscurity. During the opening decades of the 15th century, Milan remained entirely under the spell of International Gothic, while the Venetian art of the same period developed strictly along lines established in the 14th century.

Where Renaissance forms were adopted at all, they were simply added onto Gothic structures. The artistic disparities between Florence, Lombardy and Venice can be partly explained by the undoubtedly very different traditions prevalent in each region. Lombardy, owing to its geographical position and trade links, had always had closer ties with northern Europe than central Italy, while Venice remained strongly influenced by the Byzantine sphere due to its economic orientation towards the East. More important factors in the equation, however, were the very different social conditions reigning in each of the three centres.

Alongside the Church, the major patrons of art in Lombardy remained the dukes of the house of Visconti and, after 1447, those from the Sforza line. Giangaleazzo Visconti (1351–1402) planned to establish a united kingdom of Italy under his own rule – an ambitious scheme which came to naught following his early death in 1402. Venice, although nominally a republic, was in fact the most glittering oligarchy south of the Alps. Florence, on the other hand, had been governed by its citizens since the 12th century. All major official commissions were issued by the city council.

1442 — King Alfonso V of Aragon conquers the Kingdom of Naples and unites it with Sicily. His court becomes a focus of Humanism.
1448 — Iron smelters become widespread throughout Europe. 1450 — The condottiere Francesco Sforza becomes Duke of Milan.

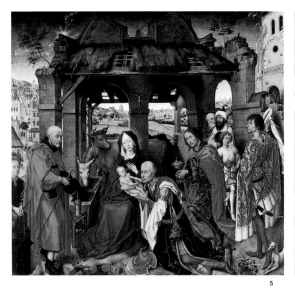
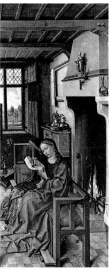

5 6

In contrast, therefore, to the art centres of northern Italy, we find in Florence a culture shaped by civic requirements. The middle classes towards the close of the Middle Ages had only partly established their own artistic traditions, however. Having risen to prosperity and political influence, they began in the years around 1400 to create their own forms of expression – forms which could draw upon tradition but were not bound to it. Church and nobility, on the other hand, had always claimed their legitimacy through tradition and were eager that this should be perpetuated into the future. For them, holding on to the forms of the past was a natural desire.

Furthermore, bankers, wool weavers and cloth merchants would have felt a much closer intellectual affinity with the phenomena of the real world than art patrons from the spheres of the Church and the nobility. The roots of the Early Renaissance may thus be seen to lie in a movement instigated first and foremost by the middle classes – their first great cultural achievement.

Since the 1430s – corresponding surprisingly closely, in other words, with Masaccio's chief phase of activity – a series of outstanding masters had emerged in Flanders and in the southwest of the German-speaking region. These artists addressed themselves to the portrayal of space, figure and landscape with the same passion as their Italian contemporaries. The Ghent Altar (ill. p. 11) was begun at some point before 1426, the year of the death of its main artist, identified in its inscription as Hubert van Eyck (c. 1370–1426). It was completed in 1432 by Jan van Eyck (c. 1390–1441). During this same period Robert Campin (c. 1380–1444) produced the first of his mature works. The *Magdalene Altar* by Lukas Moser (c. 1390 – after 1434), the *Mirror of Salvation* altarpiece by Konrad Witz (c. 1400–1445) in Basle, Campin's *Werl Altar* (ill. p. 10) and the *Wurzach Altar*

by Hans Multscher (c. 1390 – c. 1467) all date from between 1430 and 1440.

These and the works of numerous other masters took as their themes, with varying degrees of emphasis, the representation of foreshortened space, the three-dimensional figure modelled to appear like a statue, and the natural landscape. Their artistic goals thus directly paralleled those of Masaccio, Paolo Uccello (c. 1397–1475) and Andrea del Castagno (c. 1421/23–1457) (ill. p. 9). In the case of Witz and Castagno, it even led to identical ends, insofar as both perfected in their art the free-standing polychrome statue to the degree that painting and sculpture became interchangeable. In this case, the north even had the chronological edge over the south.

While fully aware of the dangers of generalization, we may thus say that in their confrontation with reality, Masaccio and the van Eyck brothers were all, and to the same degree, representatives of a new phase of development which we may call the Early Renaissance. The differences between them were the same as those characterizing both the preceding and all future stylistic epochs: individualization in the north versus idealization in the south, or in other words subjectivity in the north, and the striving for objectivity in the south, and finally – no less important – intellectualization of artistic phenomena south of the Alps, and intuition based on feeling north of the Alps.

As the North increasingly endeavoured to portray the individual as faithfully as possible, so the detail – whether in portraits, in the representation of interiors and landscapes, or in the reproduction of fabrics and trimmings – acquired a significance never attained (because never sought) in the South. The term "detail realism" has been specially coined to describe Netherlandish painting in the 15th century. It is here that several of the genres of panel painting which would

1453 — Following the Fall of Constantinople to the Turks, Greek scholars flee to Italy and influence the progress of Humanism.

1455 — Gutenberg prints his first bible with movable type.

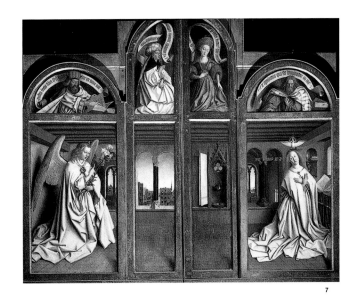

5. ROGIER VAN DER WEYDEN

Adoration of the Magi
central section of the St Columba Altar, Cologne
c. 1455, Tempera on wood, 138 x 153 cm
Munich, Bayerische Staatsgemäldesammlungen,
Alte Pinakothek

6. ROBERT CAMPIN

St Barbara right panel of the Werl Altar
1438, Tempera on wood, 101 x 47 cm
Madrid, Museo del Prado

7. JAN AND HUBERTUS VAN EYCK

Annunciation exterior of the Ghent Altar
completed 1432, Oil on wood, c. 180 x 260 cm
Ghent, St Bavo

emerge in the 16th and above all 17th century have their roots, namely the still life, the landscape, and the domestic interior. Efforts to render details with the greatest possible realism demanded new techniques and media.

Netherlandish painting of the early 15th century marked the start of a decisive new chapter in the history of colour in European painting. According to Vasari (1550), Jan van Eyck "invented" oil painting. While we may dispute the absoluteness of this claim, it undoubtedly contains a kernel of truth. The tempera techniques of previous centuries had already used oil as a binder, although other non-transparent substances, such as fig-tree sap and egg yolk, were more common. Such binders produced a colour that was absolutely opaque. Gradations were subsequently achieved by "heightening" forms with different or slightly varied shades of colour. In the age of the van Eyck brothers, oil – a transparent binder – assumed increasing importance in tempera painting, since it allowed several translucent layers of colour to be applied on top of each other. The paint surface thereby acquired a previously unknown depth and luminosity, which in turn lent the fabrics, jewellery and flowers portrayed in the new medium a naturalness touching the border between reality and reproduction and rapidly admired throughout the whole of Europe. The feastday side of the Ghent Altar marks a first climax in this development. The artistic innovations north of the Alps no more implied a "revolutionary" new beginning than in Italy; rather, they developed out of the traditions of the 14th century.

A third parallel between North and South sheds further vital light on artistic developments in the 15th century. Campin, the van Eyck brothers, Rogier van der Weyden (c. 1400–1464), Moser, Multscher, Witz and the Master of the Aix Annunciation all grew up in an intellectual climate which was strongly influenced by a civic patriciate. Internationally famed as centres of trade and industry, Ghent and Bruges, Rottweil, Ulm and Basle were free of a past shaped by a dominant ecclesiastical or feudal authority. The forms assumed by painting here were very different from those in cities where the course of the arts had been steered for centuries by the Church and powerful family dynasties, such as Cologne, or which remained closely tied to religious institutions, such as Hamburg. Thus it was possible for the Ghent Altar to arise during a period which, in Hamburg, saw Master Francke (c. 1380 – c. 1436) painting his *St Thomas Altarpiece* with its predominantly spiritual character, and which in Cologne saw the rise of a school of painting which, in the tradition of the 14th century, held firm to gold grounds, figures whose corporeality is only hinted at, and settings intended for identification purposes only. "Modern" design principles only reached the Lower Rhine with the arrival from the Lake Constance area of Stefan Lochner, mistakenly seen as the embodiment of Cologne painting. Lochner fused the heritage of his Swabian home with Cologne tradition in a highly sensitive way.

Regional differences were thus as pronounced north of the Alps as they were in Italy. Here, as there, they arose out of different social conditions. "Progressive", or in other words "Renaissance" trends issued from the sphere of the middle classes. The thesis that the Early Renaissance was the first great cultural achievement of the middle classes is thus confirmed in the North. The polarization of Early Renaissance and Late Gothic thereby naturally appears in a very different light. There was no fundamental difference between Italy and the art centres north of the Alps, but rather a distinct line drawn between tradition and "progress", one which cannot be expressed in geographical terms since it was largely determined by patrons' wishes.

1458 — Ferdinand I, King of Naples, makes his court a centre of Renaissance culture.
1469 — The Portuguese seafarer Vasco da Gama is born; in 1498 he discovers the sea route to India.

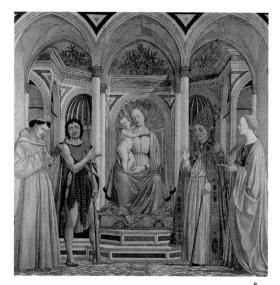

"ʙeing invited to Florence, the first thing which he did there was to paint a Madonna in fresco in a tabernacle surrounded by other saints… ʙecause this work gave great satisfaction and was much admired by the citizens and artists of the time, the envy and wrath in the vile mind of Andrea del castagno only increased against poor Domenico. Accordingly he determined to accomplish by deceit and treason what he could not do openly without manifest danger."

Giorgio Vasari

8

The Early Renaissance was indeed a decisive step along the path leading away from a theocentric world picture, i.e. one in which God is the prime concern, towards an anthropocentric world picture in which man is the measure of all things. If it had been the task of medieval art to communicate a message of salvation which went beyond that which could be experienced with the senses, painting and sculpture were now determined by direct sensory perception. Although the symbol was not replaced by the illustration, the symbolic was now expressed through the illustrative. The thesis that art underwent a secularization in the age of the Early Renaissance is nevertheless one to be vigorously refuted. In terms purely of volume, for one, there was little growth in secular painting over previous centuries. It is all too easy here to draw the wrong conclusion from the corpus of surviving works. Secular painting in the Middle Ages was chiefly limited to murals. We know that castles, palaces and wealthy town houses were decorated with large-scale mural cycles. Mural painters in the Middle Ages employed a secco technique which involved painting onto a layer of plaster which had already dried. Works executed in this manner were not very durable and offered little resistance to weathering. Thus the entire body of medieval mural painting, sacred as well as secular, has today been reduced to a fraction of its original size. Furthermore, we can also place the number of secular murals deliberately destroyed as higher than those in church interiors suffering the same fate.

Other points, admittedly, are more important. We may speak not of a trend towards secularization in the realm of sacred art, but rather of a shift of emphasis in the understanding of what actually was sacred. Thus the "rediscovery" of nature as worthy of representation had important roots in the Franciscan movement. When St Francis sang the praises of Brother Sun and Sister Moon, when he glorified God's creation in birds and plants, he directly pointed art in the direction of new pastures.

Not so directly tangible, but indirectly of no less significance, was the theology of the German Dominicans, and in particular mysticism. When Master Eckhart (c. 1260–1328) and his contemporaries spoke of the "inner man", and when Johannes Tauler (b. before 1300 in Strasbourg of patrician parents; d. 1361) wrote: "For on this depends all: on an unfathomable relinquishing of existence in an unfathomable nothingness", they were challenging not only the worldliness of the Hohenstaufen era but also the legitimacy of illustrative qualities in art.

The painting and sculpture of the early 14th century north of the Alps reflected this concept of a "relinquishing of existence", of "withdrawing from the world of appearances" (Goethe) in many different ways. Yet in speaking of the individual, the representatives of mysticism revealed a different, extremely "modern" side to their religion: on the one hand, it preached a renunciation of worldly pleasures, and thereby appeared thoroughly medieval; on the other hand, however, it was characterized by an individualism unknown in the Middle Ages.

Mutually related changes in religious thought and in society thus led to a new appreciation both of the individual and of God's creation as experienced via the senses. This process was reflected in the art of the 14th century and found a provisional conclusion in the Early Renaissance. The aim was not to identify an independent aesthetic value in the world of empirical experience, but to explore – in the areas of perspective and proportion, for example – the order of the God-created cosmos.

Parallel lines of development and related artistic phenomena raise the question of possible interaction between the north and the

1469 — Venice becomes the centre of printing and the book-trade.
an artistic centre under the Este dynasty.

1471 — Ferrara becomes a duchy and
1472 — Dante's "Divine Comedy" is printed for the first time.

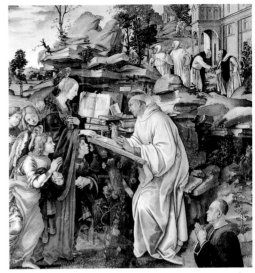

8. DOMENICO VENEZIANO

<u>Madonna and Child with Saints</u>
Sacra Conversazione
1439/40, Tempera on wood, 210 x 215 cm
Florence, Galleria degli Uffizi

9. FILIPPINO LIPPI

<u>The Vision of St Bernard</u>
c. 1486, Tempera on wood, 210 x 195 cm
Florence, Badia Fiorentina

9

south. To what extent were there direct exchanges across the Alps in the 15th century? There is no reason to suggest that it was fundamentally uncommon, in the Middle Ages and the early years of the Renaissance, for sculptors and painters who had completed their apprenticeships to spend a few years as travelling journeymen. The fact that the historical records remain silent on the matter should not tempt us to draw hasty conclusions. In the sketchbook of Villard de Honnecourt (active c. 1230–1235), for example, we possess the priceless testimony of a travelling architect. We also know that Jean Fouquet (c. 1415/20 – c. 1480) and Rogier van der Weyden made trips to Italy around the middle of the century, and that Joos van Gent (c. 1435 – after 1480) was active at the Urbino court from 1472 to 1475. Written records, too, tell us that Francesco Sforza (1401–1466), Duke of Milan, sent the painter Zanetto Bugatto (d. 1476) to train under van der Weyden for three years; the letter of thanks which the Duchess wrote to Rogier in 1463 has survived for posterity.

To dismiss such instances of artists travelling from the North to the South and vice versa as exceptions to the rule goes against the generally accepted, stylistically widely demonstrable influence which the Netherlands exerted upon the German-speaking realm. This influence extended not just to those regions geographically the closest to the Netherlandish border, but also to southern Germany. First-hand knowledge of Netherlands art was an essential part of the "education" of every good painter in the second half of the century, and may be taken as read in the case of the outstanding artists of the Early Renaissance. Remembering, however, that the mobility of Europeans remained unchanged up to the time of Goethe and beyond, we are justified in asking whether this lively artistic exchange followed an east-west direction rather than north-south.

Awareness of the latest innovations was undoubtedly transmitted through the import and export of art works. We know that Netherlandish masterpieces were collected in Venice, in Urbino, and above all in the Aragonese court in Naples. The *Portinari Altar* by Hugo van der Goes (c. 1440/45–1482), installed in Florence in 1478, also influenced Tuscan painting of the late 15th century. Written records bear witness to the fact that Italians were informed about the art of the north, and in particular about its high quality. In his *De viribus illustris* (Illustrious Men), written between 1455 and 1457, the Neapolitan Bartolomeo Facio (c. 1405–1457) named Gentile da Fabriano (c. 1370–1427), Pisanello (1395–1455), Jan van Eyck and "Rogerius Gallicus" (i. e. Rogier van der Weyden) as the four most famous painters in the world. Facio thus accorded North and South proportionally equal importance, although he strikingly makes no mention of the masters who, for us, were the founders of the Early Renaissance in Italy. A few years later, Giovanni Santi (c. 1435–1494), father of Raphael (1483–1520), also named Jan van Eyck and Rogier van der Weyden as amongst the most important artists of the century – albeit alongside a host of Italian masters.

In the north, no comparable written records have survived. We should thereby remember that a "modern" sense of history emerged earlier in Italy than north of the Alps, and that archive material was also better preserved in the South during the following centuries. We may confidently assume, however, that Italian Early Renaissance paintings would have been collected by the big Tuscan business houses and banks and displayed in their Netherlands offices, where they would have been accessible to local artists. Did an artist such as Domenico Veneziano (c. 1410–1461), about whose training and early years we know next to nothing but whose painting demonstrates a mastery of light and atmosphere previously unseen in Italian art (ill. p. 12), devel-

1481 — **The Spanish Inquisition is instituted.**
1490 — **Ballet appears at the Italian courts.**

1482 — **Printing has spread throughout Europe.**
1491 — **Humanist philosophy emphasizes the importance of individual education.**

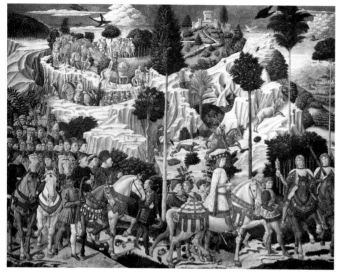

10. BENOZZO GOZZOLI
Procession of the Magi
1459–1461, Fresco, width c. 750 cm
Florence, Palazzo Medici-Ricardi

11. SANDRO BOTTICELLI
The Birth of Venus
c. 1484, Tempera on canvas, 172.5 x 278.5 cm
Florence, Galleria degli Uffizi

10

op his new technique simply from studying individual works by Netherlands artists, or could it be that he actually spent time in the north? Did the Florentine Alessio Baldovinetti (1425–1499) absorb the strong Netherlandish influences which characterize in particular his landscapes in the very country of their origin? And asking the same question in the opposite geographical direction: had the founders of the Early Renaissance in the north – Campin, the van Eyck brothers, Moser, Witz – seen Italy with their own eyes?

stylistic change after 1450

The course of European art in the first half of the 15th century might encourage us to expect a continuous development towards the High Renaissance, the period around 1500. This expectation is fulfilled neither south nor north of the Alps. After the middle of the century, a stylistic change took place in all the artistic displines which might be termed a "Gothic revival", and which was characterized by a return to earlier traditions and in particular the International Gothic. The fact that this process took place in equal measure in the North and the South once again confirms the fundamental homogeneity of the epoch.

In historical terms, stylistic development in the second half of the 15th century appears thoroughly consistent. The major achievement of the first decades – the convincing portrayal of human figure, spatial depth and landscape in their overall combination – was followed both in the north and the south by a concentration upon finer details, with a view to "correctly" mastering anatomy, foreshortening, and the built or natural environment. The most suitable means of de-

scribing details is not the modelling of large forms, however, but the line. Van der Weyden had already begun to tread this path in the Netherlands; the same trend can be seen in Multscher's workshop in south-west Germany in the evolution from the *Wurzach Altar* (1437) to the *Sterzinger Altar* (1457/58).

In Italy, Sandro Botticelli (1445–1510), Filippino Lippi (c. 1475–1504) and Luca Signorelli (c. 1450–1523) were all protagonists of this development. This new path led away from the overall whole and towards the individual component – a trend which has numerous parallels in the history of Western art. The Italian painting of the generations after Giotto is a particularly illuminating example, and even the art of the 16th century which followed the short-lived peak of the High Renaissance would, for all its stylistic diversity, demonstrate related tendencies.

With their increasing wealth, which simultaneously signified power, they began to exhibit a desire for the glittering pomp of court society. The story of the house of Medici is an outstanding example of this development, and the frescos by Benozzo Gozzoli (1420–1497) in the chapel of the Palazzo Medici-Riccardi are the most significant art works illustrating this turnabout (ill. p. 14). We may assume that a similar change of sentiment took place in Ghent and Bruges, Cologne and Nuremberg, Ulm and, later, Augsburg, to name just a few. It was reflected not only in painting, sculpture and carving, but also in architecture. The choir of the church of St Lorenz in Nuremberg, for example, and the Town Hall in Louvain testify to the same civic desire for aristocratic display. The urge to create a separate identity in the first half of the century was succeeded after 1450 by the urge to merge.

During this same period, too, the major courts began to adapt the achievements of the Early Renaissance, a fact that served to de-

1492 — Christopher Columbus is commissioned by Spain to find a sea-route to India and chances upon the islands of Cuba and Hispaniola.
1493 — The "New World" is divided by a disposition of Pope Alexander VI between Spain and Portugal.

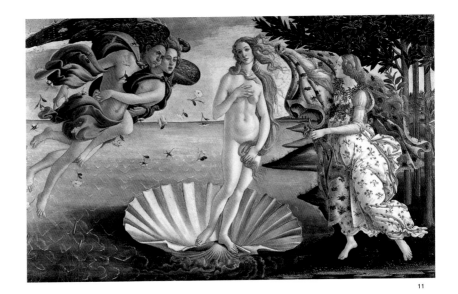

"Art is in fact the world once more, as like the world as it is unlike it."

Sando Botticelli

fuse the antagonism between the art of the middle classes on the one hand, and that of the Church and feudal society on the other. For all its backward-looking tendencies, however, the stylistic change which followed 1450 should not be misunderstood as a retrograde step. There is nothing in art history which is either a pure step "forward" or a pure step "back".

The era in European art which we call the age of the Renaissance, namely the two centuries between 1400 and 1600, reached its supreme peak in the decades around 1500. It is this brief period that we may term the High Renaissance. In every branch of art, the many and varied means of expression that had developed over the course of the 15th century were now integrated within a single, unifying concept. In the latter years of his life, Burckhardt sought to define this phenomenon. And indeed, at no other time before or since has art come so close to classical antiquity. Its aim was thereby not to imitate the past; that would have led not to "classical" art but to "classicism", as in the late 18th and early 19th centuries. Rather, it strove to reveal the ideal which lay behind the natural model.

Typical of the High Renaissance, as of all classical art, is its perfect balancing of contradictory – and hence seemingly mutually exclusive – artistic positions. Real and ideal, secular and sacred, movement and rest, freedom and law, space and plane, line and colour are thereby reconciled in a happy harmony.

By its very nature, such a perfect equilibrium of all opposing forces leaves no room for further dramatic development. It can only lead either to stagnation or to its own abolition by the artist. European, and in particular Italian, art took the latter path. It was the very protagonists of the High Renaissance – and above all Leonardo da Vinci, Michelangelo and Raphael – who thereby opened the door to new artistic possibilities. In the sense that its elements can almost all be traced back to the High Renaissance, the subsequent phase in art from around 1520 to 1600 may thus aptly be termed the Late Renaissance. It must be said, however, that High Renaissance ideas were employed by the subsequent generations, at times in an entirely new context: the vocabulary was adopted, so to speak, but the grammar was new. Against a backdrop of far-reaching cultural changes, "anti-classical" tendencies thereby began to spread which have more recently been described under the heading of Mannerism rather than Late Renaissance. In attempting to identify binding stylistic categories for the art of the 16th century, the question of an appropriate name for the epoch will need to be constantly rethought.

Painting around 1500 in Italy

Florence was undoubtedly the centre of the revival in the arts which took place during the 15th century. This should not blind us to the fact that the preliminary steps towards "classical art" were nevertheless taken outside Tuscany. Piero della Francesca (c. 1420–1492), who for all his virtuoso handling of perspective was profoundly convinced of the fundamental importance of the plane, and whose "atmospheric lighting" was at the same time highly significant for the history of colour in European painting (ill. pp. 16, 33), is thereby no less important than his fellow Umbrian Pietro Perugino (c. 1448–1523). Perugino's work was unfairly overshadowed by that of his greatest pupil, Raphael, who nevertheless owed him a very great deal (ill. p. 17). Perugino's importance lay not in his portrayal of expressive figures, but in his specifically Umbrian tendency towards spaciousness, his em-

1495 — The new epidemic disease of syphilis spreads throughout Europe.

1498 — The radical Florentine friar Girolamo Savonarola is executed.

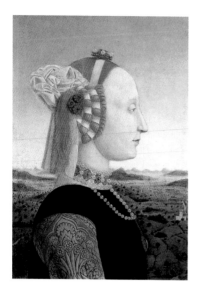
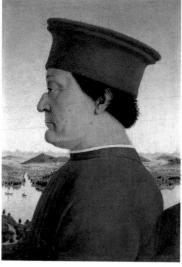

12. PIERO DELLA FRANCESCA

<u>Double portrait of Federigo da Montefeltro and his wife Battista Sforza</u>
c. 1472–1476, Tempera on wood, each 47 x 33 cm
Florence, Galleria degli Uffizi

<u>13. Pietro Perugino</u>

The Vision of St Bernard
from Santa Maria Maddalena dei Pazzi, Florence
1489, Tempera on wood, 173 x 170 cm
Munich, Bayerische Staatsgemäldesammlungen,
Alte Pinakothek

12

phasis upon landscape, his shift away from line in favour of modulated transitions, and above all his understanding of pictorial and mural surfaces as organic wholes which, although they might not yet achieve the fluency of the works of Raphael, marked a vital stage along the path to ever greater fluidity of movement.

In a very similar fashion, albeit with more differentiated means, the Venetian Giovanni Bellini (c. 1430–1516) was treading his own path towards the High Renaissance; in his late works, indeed, he became the only one of the great 15th-century painters to cross the threshold from the Early to the High Renaissance.

It was not by chance that, around 1500, the emphasis in Italian art shifted to Rome and Venice, and Florence had to relinquish its leading role. The reasons for this were undoubtedly rooted first and foremost in political and social changes. The collapse of Medici rule in 1494 and the rise to prominence of Girolamo Savonarola (1452–1498), a Dominican friar preaching an eschatological vision, brought an abrupt end to the flowering in the arts that had reached its high point under Lorenzo the Magnificent (1449–1492). After Savonarola was burnt at the stake in 1498, Florence became the political football of rival forces until the return of the Medici from exile in 1512. During precisely those twenty years in which "classical art" produced its most important works, therefore, Florence was without major patrons of the arts. Venice, on the other hand, passed from the 15th to the 16th century with its feudal ruling class still politically and economically intact, and hence with its market for art uninterrupted. Above all, however, it was the papacy which, having re-consolidated its power over the course of the Early Renaissance, now renewed its efforts to establish Rome as the cultural centre of the Western world. The appointment of Donato Bramante (c. 1444–1514) as architect of the new St Peter's in 1504, the commissioning of Pope Julius II's tomb to Michelangelo in 1505, and Raphael's move to Rome in 1509 set the seal on the city's pre-eminent position in Italian art. We may nevertheless wonder whether, under different historical circumstances, Florence would in fact have proved capable of leading the Renaissance to its climax.

In the awareness that any attempt at a broad definition inevitably involves simplification and thus approximation, we may say that the High Renaissance in Rome was concerned primarily with form, and in Venice with colour. In the sphere of painting, Leonardo was the only artist who married both at the highest level. At the same time as carrying the realistic tendencies of the 15th century to an extreme degree, he granted the geometry of the two-dimensional plane and the stereometry of three-dimensional space an importance unknown to the previous generation. Leonardo's *Last Supper* (ill. p. 18) in the refectory of Santa Maria della Grazie in Milan overwhelms the viewer with its apparent immediacy. In fact, however, the different perspective systems of real and painted space, the ideality informing even the very smallest detail of the composition, and the monumental scale of the figures ensure that we remain distanced from it. In his panel paintings, Leonardo combines these structural features with a revolutionary new use of colour. Going far beyond Piero della Francesca, Perugino and Giovanni Bellini, he increasingly replaces circumscribing, isolating line – i.e. drawing – with colour modulation. The transitions between figures and objects become fluid. Space is no longer established primarily through mathematical perspective, but by a lightening of the palette and a gradual dissolving of outlines.

Leonardo was the perfect embodiment of the ideal of the universal artist, active in every branch of art and at the same time educat-

1502 — Erasmus of Rotterdam publishes his criticisms of the Church in "Handbook of a Christian Soldier".
1504 — The largest European cities – Paris, London, Venice, Palermo, Milan, Florence, Bruges and Ghent have populations in excess of 50,000.

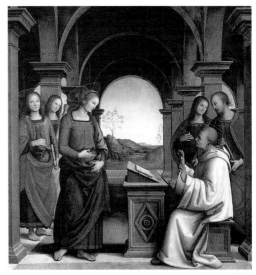

"certainly many painters who do not use perspective have also been the object of praise; however, they were praised with faulty judgement by men with no knowledge of the value of this art."

Piero della Francesca

13

ed in every field. Yet neither in Florence nor in Rome was he awarded the recognition he deserved. His departure for northern Italy, ostensibly explained by his many important commissions for Francesco Sforza (1401–1466), Duke of Milan, may ultimately have been prompted by a different, inner logic: he would both be able to further his own development and influence others in the neighbouring art centre of Venice. When, in the work of Giorgione (c. 1477/78–1510) and the young Titian (c. 1488–1576), Venetian painting stepped fully into its very own speciality, colour, it was the culmination of a development which would have been unthinkable without the influence of Leonardo.

The other aspect of Leonardo's art, the ideality of form, was taken up in central Italy. In architecture, the centralized building – i.e. one which unfolds regularly on all sides around a static centre – had been increasingly perfected over the course of the 15th century. Its counterparts in painting were symmetrical pictorial formats such as the square and the circle (tondo). The concept of centralized construction dominated not only the architecture of the High Renaissance – the plans by Bramante and Michelangelo for the new St Peter's included pure centralized buildings, possibly in a symbolic allusion to Rome as the centre of Christendom – but also determined the thinking of painters. Since only a small number of the major building projects of the period around 1500 were actually executed, our knowledge of High Renaissance architecture is largely based on the "background scenery" found in pictures, which we can take as a direct reflection of contemporary building styles. More important however, is the fact that centralizing laws of architecture indirectly came to govern the pictorial composition as a whole: sphere and circle and their mutual interpenetration thereby serve to establish an inner kinship between the construction of the painting and that of

the centralized building. In this context, the works of Raphael's mature period, and in particular his frescos in the Stanza della Segnatura in the Vatican (ill. p. 19), represent the pinnacle of High Renaissance painting.

painting around 1500 north of the Alps

Towards the end of the 15th century, with civic culture flourishing at its peak, painting in Germany rose to heights unseen since the miniatures illuminating the magnificent manuscripts of Ottonian and Salian times. In contrast to the earlier part of the century, when German artists were overshadowed by the ground-breaking achievements of their Early Netherlandish contemporaries, the situation was suddenly and astonishingly reversed in an manner which has yet to be explained either in terms of art or cultural history. Did the creative unrest brewing in Germany in the period leading up to the Reformation release new forces in the country's centres of art?

Within this development, the figure of Albrecht Dürer (1471–1528) was of outstanding importance both in artistic and historical terms. Dürer initially remained indebted to the traditions of his teachers, using line as his primary means of expression, and his early work is correspondingly dominated by woodcuts and copper engravings. In 1496 and 1506/07, however, he made two trips to Italy that would decisively influence his art. Like Johann Wolfgang von Goethe (1749–1832) three centuries later, Dürer experienced in Italian art the holistic, organic approach to composition which lay at the opposite end of the spectrum to the art north of the Alps, where painting continued to be understood as the additive combination of individual

1512 — Copernicus lays the foundations for the new heliocentric world picture, in which the Earth and the other planets revolve around the sun and the Earth is not the centre of the universe. 1515 — The Portuguese have established a large colonial empire in Africa and India.

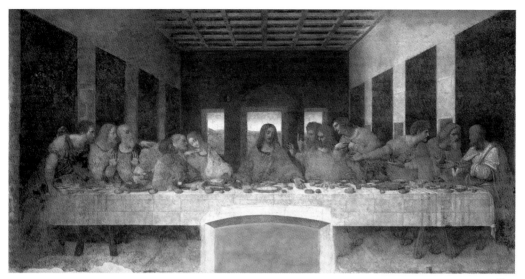

14

elements. From the Venetians, and above all from Giovanni Bellini, he learned about modulating contours with colour. Finally, too, he recognized the necessity of a sound theoretical approach to the representation of objects which went beyond mere intuition. His *Madonna of the Rose Garlands* (Prague, Národni Galeri), *Adoration of the Trinity* (Vienna, Kunsthistorisches Museum; ill. p. 61) – counterpart to Raphael's *Disputà* in the Vatican Stanze – and his *Four Apostles* (ill. p. 21) are outstanding examples of the fusion of the German and Italian feeling for form.

German painting around 1500 spanned an extraordinary breadth. If Dürer started primarily from line, Matthias Grünewald (c. 1470/80–1528) focused on composition with colour. His *Isenheim Altar* (ill. p. 63), begun around 1512, represents German art's most important contribution to the history of colour. The extent to which Grünewald drew upon the new colour theories of Leonardo and the works of Giorgione is something that deserves closer investigation. Colour modulation was also the starting-point for the painters of the so-called Danube School, and in particular the young Lucas Cranach (1472–1553), Albrecht Altdorfer (c. 1480–1538) and Wolf Huber (c. 1485–1553), at whose hands landscape painting assumed an importance previously unknown north of the Alps. Confronted with the atmospheric landscapes produced by the Danube School, one is tempted to speak of a first phase of "Romanticism" in German art.

Independent of direct contact with Italian art, meanwhile, a common tendency towards large, balanced form and towards the integration of the real and the ideal was also making itself felt elsewhere in Europe, as evidenced in the mature works of the Netherlandish artist Gerard David (c. 1460–1523), for example. David's works do not open up new avenues for the future, however, but look back to Jan van Eyck

in their understanding of the human figure as a powerfully modelled volume (ill. p. 20).

In addition to the migration both of works of art and of individual artists, from the middle of the 15th century there emerged another means of artistic exchange. At approximately the same time on both sides of the Alps, two printing techniques developed into artistic genres in their own right: the woodcut, which developed north of the Alps in the early 15th century, and – more important still – the copper engraving, whose origins probably also lay in the early 15th century in southern German art. The first dated example bears the year 1446. The earliest Italian copper engravings stemmed from the workshops of Andrea Mantegna (1431–1506) and Antonio Pollaiuolo (1432–1498). Prints provided an entirely new means of spreading artistic ideas into even the furthermost corners of Europe. The woodcut and the copper engraving thereby marked the beginning of the development of modern visual mass media. By around 1500, it may be assumed that prints were available on a wide scale – so much so, in fact, that it frequently becomes hard to judge whether an artist has appropriated a new language of form into his own work as the result of direct or indirect confrontation with its source.

Furthermore, a new, historically documented trend set in as from about 1510 which involved artists moving in both directions. Following the departure of Jan Gossaert (c. 1478/88–1533/36) for Rome in 1508, a trip to Italy became a standard part of every artist's training. This was particularly true for the so-called Romanists of the southern Netherlands. The spread of the Italian Renaissance north of the Alps was in turn encouraged by a number of important Italian painters who spent time abroad, in particular at the French court. Leonardo, who accepted an invitation from Francis I (1494–1547) to

1516 — The dye indigo comes to Europe. 1517 — The Reformation begins with Martin Luther's 95 Theses in Wittenberg.

1519 — The first circumnavigation of the globe under the captaincy of Fernando de Magellan begins.

> **"A** painter who has fat hands will paint fat hands, and the same will happen with every part of the body, unless long study prevents it."
>
> Leonardo da Vinci

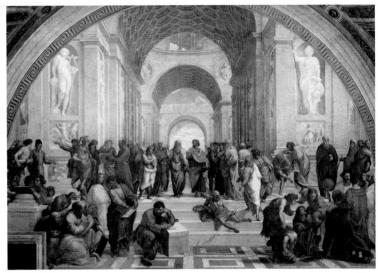

14. LEONARDO DA VINCI

<u>Last Supper</u>
c. 1495–1497
Oil tempera on plaster, 460 x 880 cm
Milan, Santa Maria delle Grazie, Refectory

15. RAPHAEL

<u>The School of Athens</u>
1510/11, Fresco, width c. 800 cm
Rome, Palazzo Vaticano, Stanza della Segnatura

15

live in France in 1516, was followed in 1530 by Rosso Fiorentino (1494–1540) and one year later by Francesco Primaticcio (1504–1570) from Bologna. Rosso Fiorentino and Primaticcio's joint decoration of Fontainebleau palace would subsequently exert a profound influence even beyond the borders of France. By the time European art began to experience this process of internationalization, however, the unity of the High Renaissance was already dissolving in a whirl of countercurrents.

Late Renaissance and Mannerism

The great works of the Renaissance – Leonardo's *Last Supper* (ill. p. 18), Raphael's *School of Athens* (ill. p. 19), Giorgione's *Sleeping Venus* (ill. p. 22) and Dürer's *Adoration of the Trinity* (ill. p. 61) and *Four Apostles* (ill. p. 21), for example – give the impression that they are definitive and complete in themselves, leaving no room for further development. It would be a misunderstanding, however, to view their progression as a more or less static line rather than as a sweeping curve. All these outstanding masters grew out of the traditions of the late 15th century, orchestrated their pictorial forces into a "classic" harmony and ultimately paved the way towards a new era in art. Their greatness lies not least in their power to transform, enabling them to confront and resolve ever new problems of composition.

For the twenty brief years of his artistic career, Raphael – whose work may be seen as the purest embodiment of the ideals of the High Renaissance – trod a path which took him, with an absolute inner logic, through a succession of entirely different landscapes. Having carried the High Renaissance to its supreme peak and defined it

for all time in his frescos for the Stanza della Segnatura in the Vatican, he immediately proceeded to explore entirely new avenues in the neighbouring Stanza dell'Eliodoro. Compare, for example, the *School of Athens* with the *Expulsion of Heliodorus*: although their underlying compositional principles are related, the two scenes can only be described in downright contradictory terms, whereby we should not overlook the very different dramatic character of the events they depict. In the *Expulsion of Heliodorus*, we are immediately struck by Raphael's renunciation of harmoniously calculated proportions approximated to correspond with the semicircular format. Above all, however, the artist abandons the central point of focus towards which, in the *School of Athens*, all lines lead, and replaces it with a centrifugal composition which creates a powerful suggestion of recession in the perpendicular middle axis. The previously equal balance between plane and space is now tipped in favour of the third dimension. The movement from foreground to background is accelerated by rapid switches between light and shade, whereby the harmony of line and colour simultaneously begins to yield to painterly effect. *The Release of St Peter*, also in the Stanza dell'Eliodoro, explores the same direction. Raphael's journey culminated both logically and chronologically in his last work, *The Transfiguration* (ill. p. 65). The balanced weighting of the *School of Athens* here gives way to asymmetrical arrangement, while highly dynamic gestures and movements create a new form of pictorial unity which the spectator must actively assimilate. Raphael distinguishes between the two different planes of reality – that of the mir painting around 15 acle and that of the earthly zone below – in the treatment of his figures and in the handling of his pictorial means. There takes place in Raphael's œuvre a development from closed to open form, from plane to recession, from unity to multiplicity.

1521 — The Spaniard Hernando Cortez destroys the Aztec state in Mexico.

1525 — Albrecht Dürer writes the first textbook in German on perspective geometry.

19

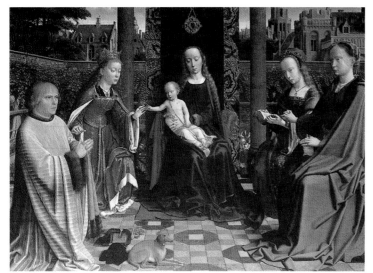

16. GERARD DAVID
<u>The Mystic Marriage of St Catherine</u>
c. 1505–1510, Oil tempera on wood, 106 x 144 cm
London, National Gallery

17. HANS HOLBEIN THE YOUNGER
<u>Darmstadt Madonna</u>
c. 1528/29, Oil on wood, 146.5 x 102 cm
Frankfurt am Main, Städelsches Kunstinstitut Galerie

18. ALBRECHT DÜRER
<u>Four Apostles (John, Peter, Paul and Mark)</u>
1526, Oil on lime, each 204 x 74 cm
Munich, Bayerische Staatsgemäldesammlungen,
Alte Pinakothek

16

With the exception of the sculptures produced when he was barely thirty, such as the *David* (1501–1504), the œuvre of Michelangelo is the hardest to correlate with the normative ideals of the High Renaissance. Michelangelo was already overstepping the bounds of the High Renaissance in his frescos for the ceiling of the Sistine Chapel in the Vatican (1508–1512; ill. pp. 4, 55). Contrary to first impressions, the enormous cycle does not obey a single system of perspective, but is composed "multi-perspectivally" with individual sections each obeying their own laws. The striking contrasts in scale evident between the Sibyls and Prophets, the ignudi (the naked young men), and the figures in the story of Creation remove any impression of a closed order. The boundaries between architecture, sculpture and painting have become transparent. In the figures of the ignudi, Michelangelo liberates himself from the constraints of iconographical tradition both in terms of form and content. In the urgently increasing freedom which he grants to pose and movement, Michelangelo's future path lies revealed: the representation of the human figure as a statement of personal experience and suffering.

Leonardo, the oldest member of the great triumvirate of the Italian Renaissance, also crossed the border from the High to the Late Renaissance in his last works, insofar as he allowed his figures and objects to recede as if behind a veil – a technique which Vasari called sfumato (It. *sfumare* = to soften, shade off). In this Leonardo contradicted a fundamental principle of the High Renaissance that he had himself helped to establish: "classic art" was characterized not least by daylight clarity and tangibility.

North of the Alps, a tendency towards cool distance and scepticism, especially in portraiture, began to emerge amongst the younger members of Dürer's generation, in particular Hans Holbein the Younger

(c. 1497/98–1543) and Hans Baldung Grien (c. 1484/85–1545), as well as in Altdorfer's late works. Hand in hand with this trend went a growing interest in secular subjects – Holbein's *Madonna of Mercy* (ill. p. 21) of 1528/29 would be his last religious painting! Erotic scenes, foreign neither to the Early Renaissance nor to the Middle Ages, assumed a previously unknown importance, particularly since they were frequently treated outside the mythological context to which they had traditionally been confined – another indication of the crack in the holistic vision which had been one of the foundations of the High Renaissance.

The term Mannerism which is today widely used to describe the art of the Late Renaissance can be traced back, like the terms Gothic and Renaissance, to Vasari's *Lives of the Artists*, a selection of biographies of Italian artists from Cimabue to Vasari's own times, first published in 1550 and reprinted in a second, expanded edition in 1568. In his book Vasari wrote of Michelangelo's maniera, by which he simply meant "manner" in the sense of "style". Understood in this light, Michelangelo's maniera can indeed to be said to have influenced not just the 16th century but much of the Baroque era, too. Having a similar sound but a different meaning was the concept of manière which had existed in the history of French literature since the late Middle Ages. Manière denoted behaviour in accordance with one's social standing, and thus lay at the root of our own phrase "to have good manners". Both words thus started out with thoroughly positive connotations. During the transition from the late Baroque era to early Neoclassicism in the second half of the 18th century, however, they came to be used in a derogatory sense to imply behaviour that was "mannered", in other words artificial, exaggerated and even peculiar. In the late 19th century, art historians adopted "Mannerism" as a pejo-

1531 — A large comet, later to be known as Halley's Comet, appears and awakens superstitious fears.

1533 — The Inca empire in South America is destroyed by the Spanish conquistador Francisco Pizarro.

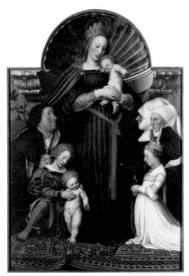
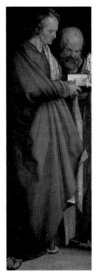
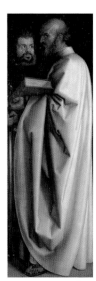

> "The art of painting is a service to the church, in order to portray the sufferings of christ and other good models; it also preserves the likenesses of men after their death."
>
> Albrecht Dürer

17 18

rative term for the trends in art from around 1520 to 1600 which, from the standpoint of a classicist aesthetic, were perceived as corruptions of the High Renaissance. Since the opening years of the 20th century, however, recognition of the profound artistic innovations wrought by Mannerism has led the term once again to be used in an increasingly positive sense.

As a name for a stylistic phenomenon in European art, Mannerism nevertheless remains problematic. The common foundation of the art of the 16th century was the High Renaissance, even if its ideals and standards were frequently exceeded or even destroyed. In this respect, it was an era which virtually made contradiction one of its principles. It is nevertheless impossible to formulate a succinct definition of Mannerism – unless it be within a very general framework, reduced to the common denominator of contradiction or the self-contradictory. Rather than use the term Mannerism, we might more cautiously speak of a broad range of "mannerisms" in the art of the years between 1520 and 1600, whereby it should be remembered that the centre of European art in the 16th century, Venice, and its most important representative, Titian, both largely defy such categorization.

By its very nature, representational art can capture either just one specific moment or, in what is known as continuous representation, several moments occurring in chronological succession. For the first time in the history of Western art, however, the painting and sculpture of the 16th century made the visual suggestion of movement their primary challenge. In painting, this particularly affected subjects involving the dimension of time, such as Ascensions and Assumptions, Depositions and Entombments. This development began during a period generally still identified as the High Renaissance. Its grandiose beginnings were provided by Titian's *Assumption of the Virgin* painted

for Santa Maria Gloriosa dei Frari in Venice in 1516–1518, and Raphael's contemporaneous *Transfiguration* of 1517–1520.

Just how strongly the painting of the 16th century was gripped by the desire to render movement visible is demonstrated by the fact that it introduced a chronological dimension even into those pictorial themes which, by their very nature, seemed destined to remain static and still. This can be seen, for example, in Sacra Conversazione paintings of the Virgin and Child surrounded by saints. The *Madonna della Arpie* (1517; Florence, Galleria degli Uffizi) by Andrea del Sarto (1486–1530), Titian's *Pesaro Madonna* (1519–1526; Venice, Santa Maria Gloriosa dei Frari) and, already bordering on the eccentric, the *Madonna di San Gerolamo* (c. 1530; Parma, Pinacoteca) by Correggio (c. 1489–1534) herald the start of a development in which figures, while retaining their traditional air of introspective contemplation, are grouped within a dynamic circular or ascending compositional structure.

Florence now once again assumed a leading role. Returned to political stability and freed from the demand for classical equilibrium, the dialectic Florentine nature rose to the challenge of creating an art in which the contradictory was no longer integrated, but exposed in all its tensions. Under the leadership of Pontormo (1494–1556) and Rosso Fiorentino, Florentine Mannerism would make its influence felt far beyond the borders of Tuscany (ill. p. 24). In his *Visitation* (c. 1530; Carmignano church, near Florence), Pontormo transformed a traditionally stately theme into an incessantly turning "roundelay" which, for all its stylistic differences, is closely related in its basic organization to Titian's *Christ Crowned with Thorns* of 1576.

Closely related to the challenge of rendering movement visible was the 16th century's new approach to space. Both in architecture

1541 — Ignatius of Loyola, the first General of the Jesuit Order, pursues the idea of a World Mission. 1547 — Leaflets become increasingly widespread as a news medium. 1550 — Many princely courts establish art galleries and cabinets of curiosities.

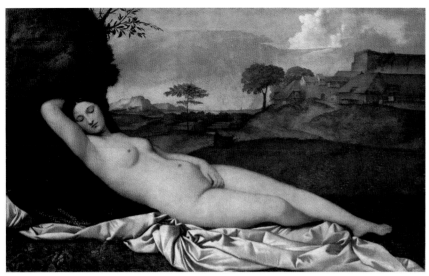

19

and painting, the Early and High Renaissance had established clear, defined space; in contrast to the diaphanous – i.e. largely dematerialized and transparent – wall systems employed in the Gothic era, the limits of space were experienced as finite and provided the viewer with a secure framework and a fixed point. In the course of the 16th century, however, the nature of pictorial space underwent a profound transformation. The two opposite poles of this development can be seen in Leonardo's *Last Supper* of 1496–1498 and the version which Tintoretto (1518–1594) painted a century later (1592–1594; Venice, San Giorgio Maggiore).

For all his virtuoso handling of perspective, Leonardo always keeps in sight the conditions imposed by the two-dimensional plane; Tintoretto, on the other hand, not only allows his space to recede into depths which the eye can no longer clearly grasp, but at the same time removes its lateral boundaries: space loses all rationally comprehensible dimension.

This development can be broken down into a series of chronological stages. In the first step, the balance between plane and space is relinquished in favour of the dominance of space. In a second stage, pictorial space is expanded seemingly to infinity; in many cases, the eye is drawn with confusing speed along a straight line in the central axis far into the depths of the painting. Instead of alighting upon a final "goal", however, it is left to lose itself in the distance. (Just how close painting can come to architecture in this respect is revealed by a comparison of Tintoretto's scenes from the legend of St Mark in Venice and the Uffizi in Florence, begun by Vasari in 1560.) Finally, not only is pictorial space granted unlimited depth, but its lateral boundaries are made permeable.

Painters north of the Alps used different means to create the impression of infinite space, since they did not have at their disposal

the various methods of foreshortening which had been increasingly refined in Italy over the course of the 15th century. They developed instead a type of "global landscape" viewed from a bird's-eye perspective – a genre which must be seen as closely related to the history of the map. Netherlandish painting after Joachim Patinir (c. 1480–1524), in particular, took up this new landscape form.

The 16th century, on the other hand, carried the principle of the fusion of real and artificial space far beyond the Early Renaissance. In the decorations which the Sienese artist Baldassare Peruzzi (1481–1536) carried out in 1508–1511 in the Sala delle Prospettive (Room of Perspectives) in the Villa Farnesina in Rome, painted architecture appears to open out onto a view of the surrounding Trastevere district. Vasari, too, plays upon spatial boundaries in his frescos for the main room of the Palazzo della Cancelleria in Rome, called the Sala dei Cento Giorni (Room of the Hundred Days) from the time it took him to paint it. The eye is thoroughly confused as walls appear to open up outwards even as stairs and figures appear to penetrate the real interior of the room. Paolo Veronese (1528–1588) would take this to an extreme in his decorative scheme for the Villa Barbaro in Maser, near Treviso, begun in 1561 (ill. p. 25), in which landscape views are combined with trompe l'œil architecture and figures created with purely painterly means.

Veronese is also an illustration of the blurring of boundaries of a different kind, namely those between the individual branches of art. The replacement of one genre by another – of sculpture by painting, for example, or of architecture by sculpture – was something that dated back to the late Middle Ages. Following the rise of grisaille in Cistercian glass painting during the 12th century, sculpture was frequently imitated by painting. In the Early Renaissance, painted figures

1556 — Under its new king, Philip II, Spain becomes the leading colonial power.

1562 — France is torn by the Wars of Religion which continue with interruptions until 1598.

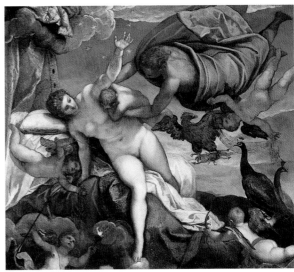

"it is not bright colours but good drawing that makes figures beautiful."

Titian

19. GIORGIONE & TITIAN

Sleeping Venus
c. 1510/1512, Oil on canvas, 108 x 175 cm
Dresden, Staatliche Kunstsammlungen,
Gemäldegalerie Alte Meister

20. TINTORETTO

The Origin of the Milky Way
c. 1575, Oil on canvas, 148 x 165.1 cm
London, National Gallery

20

often resembled polychrome statues. Not until the 16th century, however, did this trend towards the interchangeability of the arts reach its fullest expression. In his work on the Sistine ceiling, Michelangelo drew increasingly closer to the category of the free-standing figure. In his decoration of the Camera di San Paolo in the convent of the same name in 1518/19, Correggio not only abolished fixed visual boundaries for the ceiling but used painting to suggest the presence of sculptures and architectural elements. It was Veronese in the Villa Barbaro, however, who once again went furthest towards dissolving the barriers between architecture, sculpture and painting.

In all its forms considered so far, the Mannerist art of the 16th century rejected the norms of the High Renaissance. Mannerism was fundamentally "anti-normative", albeit not yet "manneristic" in the modern sense of the world. "Mannered", on the other hand, is a term which can be applied to a series of phenomena which up till now have served to overly colour our opinion of the era.

The most important of these is the deformation of the ideal human figure, frequently as a means of heightening expressiveness. Thus Rosso Fiorentino, who undoubtedly studied the work of Michelangelo (ill. p. 24), transposed the latter's Herculean image of man into figures of seemingly arbitrary proportions and into forms whose details are often generously condensed. In Florentine painting especially, figures frequently possess elongated bodies with relatively small heads. This principle, which would be taken up by El Greco (c. 1541–1614) at the end of the century (ill. pp. 24, 95), was first exploited to particular effect by Pontormo.

In the *Self-Portrait in a Convex Mirror* (Vienna, Kunsthistorisches Museum) which he painted in 1523, Parmigianino (1503–1540) made the distortion of the human ideal cultivated by the High

Renaissance his overt theme. The Milan painter Giuseppe Arcimboldo (c. 1527–1593) came close to Surrealism in the heads which he composed entirely out of plant life or which he placed in unreal, dreamlike settings.

Last but not least, this distortion of the human and natural image extended to anti-classical unnatural colour combinations, as found in particular in 16th-century Florentine painting, and to the use of non-uniform systems of perspective and scale to subvert the logic of the whole.

To generalize, and hence inevitably to simplify, we may identify in the art of the Renaissance three successive stages in the portrayal of the human figure. The ideal of the Early Renaissance was man in his natural image. The ideal of the High Renaissance was the idealization of that natural image, the portrayal of man in the state of full harmonious development which in real life he is prevented from attaining. The "ideal" of Mannerism was go beyond and in part to distort man's natural image in favour of heightened expression.

forces behind the stylistic changes in the 16th century

The shift from the High to the Late Renaissance was a reflection of far-reaching religious, social and scientific developments. Unlike the reformist and "heretical" movements of the Middle Ages, which had never seriously threatened the power of Rome, when Martin Luther (1483–1546) nailed his famous theses to the door of Wittenberg church in 1517, he publicly signalled the start of a religious revolution which would fundamentally challenge the validity of the Catholic Church. The latter retaliated in the mid-16th century with the

1565 — **The first potatoes reach Europe from South America.**

1567 — **The Hanseatic League loses its power as the central institution of trade and navigation.**

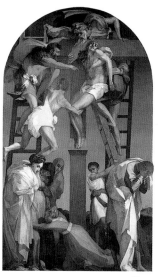

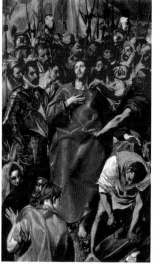

21 22

21. ROSSO FIORENTINO
Deposition
from Volterra cathedral
1521, Oil on wood, 333 x 195 cm
Volterra, Pinacoteca Communale

22. EL GRECO
The Disrobing of Christ
1577–1579, Oil on canvas, 285 x 173 cm
Toledo, Sacristy of the Cathedral

23. PAOLO VERONESE
Giustiana Barbaro and her Nurse
c. 1561/62, Fresco (detail)
Maser (Treviso), Villa Barbaro

reforms of the Council of Trent and, by summoning all its forces, restored religious life in wide areas of Europe. But the underlying damage had been done: the unquestioning acceptance with which the Church had formerly been greeted could never be restored. The 16th century was thus filled with extraordinary religious tensions which would destroy the balance between the secular and the sacred sphere, between the real and the ideal, that had so characterized the High Renaissance. For the arts in Germany, the schism remained a constant source of conflict throughout the following centuries. Luther's doctrine of the "freedom of the Christian", who is granted responsibility for himself, undoubtedly represents one of the greatest achievements in the history of German thought. In two respects, however, it also harboured dangers which would prove catastrophic on several occasions in the future. Firstly, Luther's doctrine overestimated the moral quality of humankind, a reflection of the fact that Protestantism itself required an educated mentality in order to be properly understood. Secondly, it restricted itself to man's inner freedom, while continuing to demand strict obedience to secular power. In this way Protestantism encouraged an acceptance of political authoritarianism which would prevent the development of democracy for many centuries. Luther himself experienced the negative consequences of the Reformation. Following earlier demands by rebels for greater freedoms for the peasant classes, by 1526 the Peasants' War was raging. Influenced by the new teachings, the peasants wanted a role in state life and called for the abolition of serfdom and the secular dominion of the Church. After initial successes, the rebels were crushed, primarily for lack of a leader to co-ordinate their efforts. Luther initially sought to act as mediator between the opposing sides but then came down clearly on the side of authority.

The denunciation of image worship, voiced most vociferously by John Calvin (1509–1564), led in Germany and the Netherlands to a violent wave of iconoclasm, comparable only to the burning of Byzantine paintings in the 8th century. The scale of the damage would only be surpassed by the devastation wrought by the air raids of the Second World War.

The religious conflicts which lasted throughout the 16th century would also have an enduring consequence for German culture right up to the 20th century, as described by Golo Mann (1909–1994): "Germany, which had previously shared in all of Europe's major experiences – Romanization and Christianity, feudalism and crusades, monasteries and universities, cities and the middle classes, Renaissance and Reformation – now failed to share in the greatest experience of all: the burgeoning Europeanization of the world. Her ships plied neither the Atlantic nor the Indian Ocean. Her trading activities dwindled, her cities grew poorer, her middle classes fossilized. The invaluable education signified by colonization and the battle for the colonies, its broadening of horizons and its material enrichment and intensification of life – in all these things Germany took little part."

In other words, the Reformation ushered into German culture a certain provincialism which it would be unable to shake off for centuries. The lack of major patrons was painfully evident. It was not by chance that Germany's greatest painter since Dürer, Hans Holbein, spent a large part of his life in England. Cranach, having been one of the most imaginatively talented artists around the turn of the century, descended into a cool, artificial aestheticism as court painter to Frederick the Wise of Saxony (1482–1532). The formal vocabulary of the Renaissance was explored predominantly in the ornamental sphere,

1570 — Palladio's architectural theory "I quattro libri dell'architettura" appears. **1572** — The old catapults are finally superseded by cast-iron artillery-pieces. **1577** — The Roman school of painting known as the Accademia di San Luca is founded.

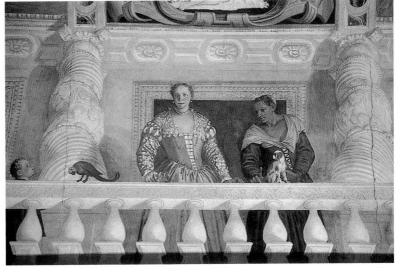

"veronese is freer than titian,
but not so perfect."

Eugène Delacroix

whereby it was not even received directly from its Italian source, but only through the indirect channel of Netherlandish art.

Alongside religious upheavals, Italy also underwent sensitive political changes in the 1520s. In 1527, and thus at approximately the same time as the Peasants' War in Germany, Italy was profoundly shaken by the sack of Rome by the mercenary armies of Emperor Charles V (1500–1558). The event was widely seen as a chastisement for the relaxation in the country's moral standards and its indulgence in luxurious lifestyles. If Italy's suffering would appease the wrath of God, wrote Jacopo Sadoleto (1477–1547), bishop of Carpentras since 1517, in a letter to Pope Clement VII (1478–1534) dated 1 September 1527, "if these terrible punishments clear the ground for a return to better morals and laws, then perhaps our misfortune has not been of the greatest." Whatever the case, people's faith in the glittering face of secular power was profoundly shaken, all the more so as broad sections of Italy remained under Spanish rule.

The "crisis in the High Renaissance" was not only rooted in historical, religious and social changes, however, but was also, and in equal measure, the consequence of a new world picture. In 1492 Christopher Columbus (1451–1506) discovered America while attempting to reach India. Between 1497 and 1504, the Florentine explorer Amerigo Vespucci (1451–1512) mounted four voyages of discovery to Honduras and South America; the "new" continent was named after him. In 1497/98 Vasco da Gama (c. 1460–1524) succeeded in sailing round the southern tip of Africa and in finally establishing the sea route to India. Amongst the new territories discovered by others charting the same course were southern China in 1517, New Guinea in 1526 and Japan in 1542. In 1519–1522 an expedition captained by Ferdinand Magellan (c. 1480–1521) embarked

upon the first circumnavigation of the world – an astonishing achievement and an important milestone in the history of geography. The vast new continent of America was explored in greater depth in the 1520s and 1530s; from 1528, the Spaniards penetrated deep into North America from their outposts in Mexico, and in 1534 the French occupied parts of Canada.

In this respect, the 16th century was the era of a quite literally changing world view. The self-contained Old World was now obliged to recognize its relativity to the whole. It no longer ranked as the centre of the world fringed by a few more or less exotic outskirts, but simply as a comparatively small area within a large, for the most part unexplored horizon. The multiplicity of these newly-discovered landscapes, peoples and cultures cast into question the validity of Europe and its outlying regions as the measure of all things.

It was only logical, therefore, that a new definition should be required for the concept of virtually immeasurable dimensions, of infinity. It is undoubtedly here that we find the roots of the new approach to space demonstrated in the art of the epoch.

The world picture would also take a turn in another direction in the early 16th century when, following on from work already carried out by the German astronomer Regiomontanus (1436–1476), Nicolaus Copernicus (1473–1543) began to formulate his revised theory of planetary motion. The heavenly bodies revolved not around the earth, he argued, but around the sun; the earth, too, revolved round the sun and at the same time spun on its own axis. Some one hundred years later, in 1633, Galileo Galilei (1564–1642) would be forced to recant his belief in this heliocentric world picture.

1588 — The Spanish Armada is defeated by the English fleet under Sir Francis Drake.
1590 — The Italian scientist Galileo Galilei carries out experiments with falling bodies from the Leaning Tower of Pisa.

тhe тrinity

Fresco, 667 x 317 cm
Florence, Santa Maria Novella

*** 1401 San Giovanni Valdarno
(Arezzo), † 1428 Rome**

Masaccio is considered the greatest master of Italian Early Renaissance painting. Within a time span of about five years he practically formulated the pro- gramme for future generations. Little is known about his train- ing. Decisive for his develop- ment were the great Florentine sculptors Donatello and Nanni di Banco, and he also explored the early works of Brunelleschi. In the field of painting the only adequate comparison possible is with Giot- to: over a period of about a cen- tury, Masaccio was the only painter whose work ranked with that of Giotto, in that Masaccio used all painterly devices at his disposal to convey genuine human feeling.

In 1422 he was appointed master of the Florentine guild. From 1424 he worked with Masolino on the decoration of the Brancacci Chapel in the Carmine in Florence, creating a little later the great fresco of the Holy Trinity in Santa Maria Novella. With these works he achieved the high point of his artistic creativity, showing absolute assurance in the use of the perspective system together with the ability to suggest the mass and volume of objects in the round. Architecture and land- scape appear natural but do not serve as ends in themselves. As in the works of Giotto, they are used to heighten the central scene, further emphasised by a completely novel handling of light and shade.

Masaccio's Trinity fresco, painted for a Florentine patrician family yet to be definitively identified, is one of the founding works of Renais- sance painting. Here, for the first time, three-dimensional space is projected onto the two-dimensional plane with the aid of the linear

perspective newly rediscovered by Filippo Brunelleschi. Solid wall truly appears to have been breached – the foundation of all later "illusionis- tic" painting in which reality and appearance are rendered indistin- guishable to the eye, and above all that of Mannerism and the Baroque.

Masaccio enables the viewer to identify directly with the painted world of the fresco by portraying the figures in life size and by calculating the perspective from the very position of the onlooker in real space. While the forms of the architecture are borrowed from antiquity, they are also to be found in the first works of Early Renais- sance architecture, such as San Lorenzo by Brunelleschi and the sculptured tabernacle in Orsanmichele by Andrea Orcagna – refer- ences through which the artist again lends his fresco an overwhelm- ing degree of realism.

The Trinity should be appreciated not simply for its revolutionary illusionistic qualities, however, but also for the highly intelligent organ- ization of its figures. The donors kneeling in front of the framing pilasters lend depth to the foreground and reinforce the connection between the viewer and the fresco. At the same time, the grouping of all the figures into a steep-sided triangle – a geometric form – acknowledges the frontality of the plane.

> **"мasaccio began painting at the time when мasolino da рanicale was working in the вrancacci chapel in the carmelite church at Florence… мasaccio made more use than other artists of nude and foreshortened figures, which indeed had rarely been seen before."**
>
> **Giorgio Vasari**

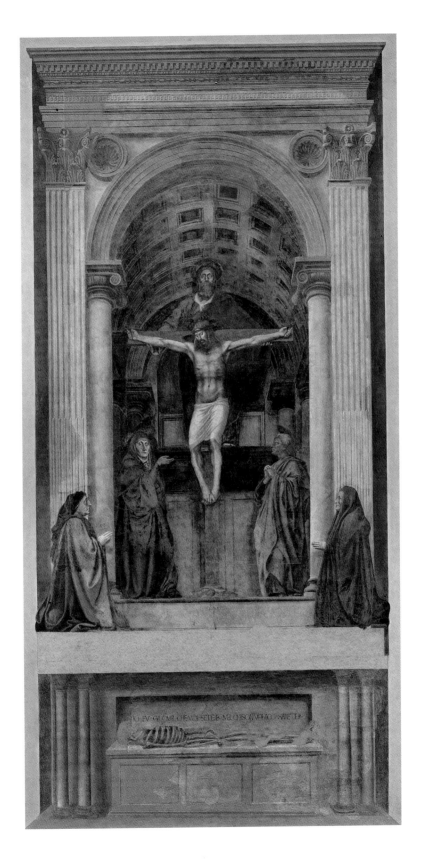

The coronation of the virgin

Tempera on wood, 209 x 206 cm

Paris, Musée National du Louvre (from the priory church of San Domenico, Fiesole)

*** c. 1395–1400 Vicchio di Mugello (near Florence), † 1455 Rome**

Angelico came from a well-to-do family and learned his craft from obscure painters and miniaturists. On completing his training he entered the Dominican priory at Fiesole, between 1418 and 1421, where a strict rule was observed. This reformed branch of the Dominican order enhanced the prestige and intellectual importance of the order in the Tuscan region. Angelico held various offices as a friar, such as that of prior between 1450 and 1452. During his beatification process at the beginning of the 16th century it was claimed on various occasions that Fra Angelico was to have been appointed Archbishop of Florence in 1446 but that, at his own suggestion, the friar Antoninus (who was later canonised) was given the office. This suggests that the painter was by no means just a naive, contemplative friar, detached from reality. In 1436 Cosimo de'Medici left the San Marco monastery in Florence to the reformed Dominicans, using it as a private family chapel, and both the church and the priory were restored at his expense. The architect Michelozzo added some new parts, including the famous library. Fra Angelico carried out the paintwork with the help of assistants between 1436 and 1445 and also after 1449. Angelico did not only undertake work for churches and monasteries of his own order, but was also some years in the service of the popes in Rome (the chapel of St Nicolas in the Vatican still remains) and in Orvieto where, according to records, he worked in 1447 with four assistants, amongst them Gozzoli.

Fra Angelico was a contemporary of Masaccio. Artistically, however, he tended towards the masters of the 14th century, such as Orcagna, and the somewhat older painters like Lorenzo Monaco and Gentile da Fabriano. With his advancing age the new discoveries of Masaccio and other young Florentines became detectable in his handling of light and the architectural severity of composition. With regard to figures and surroundings he upheld his deeply spiritualised ideal. This religious ideal of "sweetness", as it was called in contemporary tracts, had been a dominant feature of monastic piety in the 12th century.

The Coronation of the Virgin was a triumphal subject which was excellently suited for an altarpiece. It was believed that, at the moment of the consecration of the Host on the altar, the heavens opened and the community of Heaven, i. e. the Church triumphant, took part in the sacrifice of the Mass. Since theology taught that the Church was, in a mystic fashion, identical with Mary, the Mother and at the same time the Bride of Christ, this painting of Mary's coronation is also a metaphorical picture of the triumph of the Church.

This idea was particularly welcome to the Dominicans, who had made it their goal to strengthen papal power and defend it against all critics and deviationists. This also explains why many members and patrons of the order of the Black Friars are portrayed amongst the saints in this celestial gathering. One of the scenes on the predella underneath shows St Dominic supporting the walls of the church against collapse, illustrating the order's understanding of its role.

> **"Fra Angelico's religiousness must be considered from a historical perspective, that is, as thought and action aimed at saving the religious essence of art threatened by the new culture of humanism."**
>
> **Giorgio Vasari**

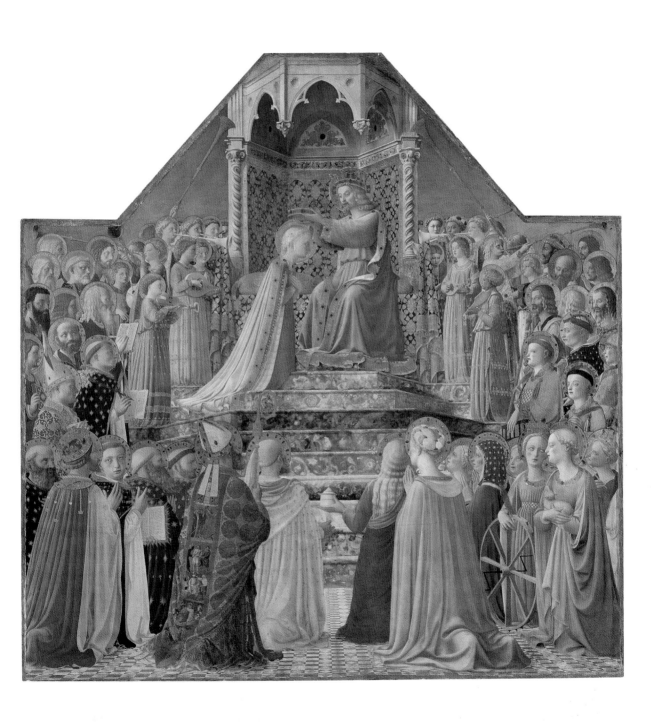

equestrian portrait of sir John Hawkwood

Fresco, transferred to canvas, 732 x 404 cm
Florence, cathedral

* 1397 Pratovecchio (near Arezzo)
† 1475 Florence

Uccello was one of the most versatile founders of the Italian Early Renaissance, although his later reputation did not reflect his true significance. His first formative experience came from working with Ghiberti, whom he assisted with the decoration of the paradise doors of the Florence baptistry. Nothing survives of his contribution to the mosaics of San Marco in Venice, but his frescos of the Genesis in the Chiostro Verde of Santa Maria Novella in Florence (c. 1430) show that he was a follower of Ghiberti and that he was firmly rooted in the International Gothic style (Gentile da Fabriano, Pisanello). It comes therefore as a great surprise to note his change of direction in the 1430s. Developing an intense interest in perspective under the influence of Masaccio's and Donatello's works, he became engrossed in the problem of rendering figures that would stand out in space and appear solid and real. His first great achievement was the equestrian picture of John Hawkwood, followed by the Noah scenes in the Chiostro Verde in Santa Maria Novella (c. 1450), which anticipate Mannerist pictorial construction, such as the spatial "crater" in the Flood scene with its effect of compelling the eye to travel down into the depth. Proof of Uccello's obsession with perspective are his drawings in the Uffizi of objects which he made look transparent in order to be able to show them in their stereometric complexity. Unfortunately he outlived his own time: after painting his three scenes of the *Battle of San Romano*, commissions dwindled away as general taste changed and demanded courtly refinement.

Behind this work, signed and dated 1436, lies a lengthy history. Sir John Hawkwood was an English mercenary leader known in Florence as Giovanni Acuto. An original plan to honour his distinguished name with a marble tomb was shelved, for reasons of cost, in favour of an equestrian portrait, duly painted by Agnolo Gaddi. Deemed old-fashioned in 1433, this was replaced by the present work, in which Uccello uses the new means of foreshortening and three-dimensional figure representation to create a "painted sculpture".

The base appears to project out of the wall on three consoles. The view of the coffered underside creates a sense of tangible three-dimensionality which is reinforced by the muted palette. In light of the numerous preliminary studies for stereometric bodies surviving from Uccello's hand, we may assume that here, too, the foreshortening of the individual architectural elements was precisely calculated in advance. So important did Uccello consider the brilliant rendition of the three-quarter view and underside of the base that he was willing to compromise the integrity of the perspective system governing the overall composition. Thus base and rider are in fact seen from different angles – the base from below and the rider in strict profile from the side. It would be wrong to deduce from this that Uccello changed his mind half-way through. There could be no question of a worm's-eye view for the heraldic figure of the rider, and in Uccello's eyes the bravura composition of the base made up for the break in perspective. Horse and rider, powerfully modelled, stand out forcefully against the dark background. The influence of sculpture first felt in Masaccio's painting ten years earlier now fully determines Uccello's figural style.

"what a delightful thing this perspective is!"
Uccello, after Vasari

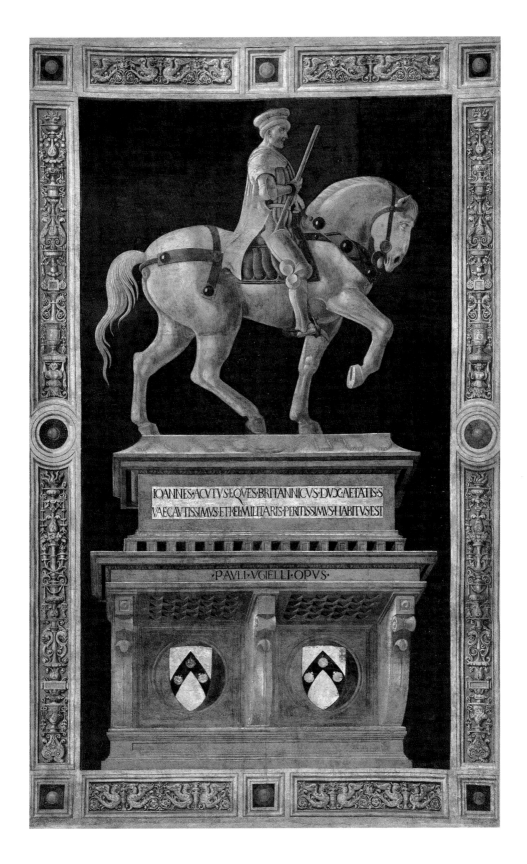

IOANNES·ACVTVS·EQVES·BRITANNICVS·DVX·AETATIS·S
VAE·CAVTISSIMVS·ET·REI·MILITARIS·PERITISSIMVS·HABITVS·EST

·PAVLI·VGIELLI·OPVS·

тhe вaptism of christ

Tempera on wood, 168 x 116 cm
London, National Gallery

Piero was probably trained in a Sienese-Umbrian workshop, where he developed his power as a colourist and his interest in landscape painting. Between 1439 and 1445 he explored the new ideas on space and physical form of the Florentine Early Renaissance, and he experimented with colour while assisting Domenico Veneziano with the now lost fresco cycle in San Egidio (now Santa Maria Nuova). By adding a larger proportion of oil as binder it was possible to achieve atmospheric lighting effects. As Veneziano's successor, Piero became a pioneer in this field. After 1452 he created his most famous fresco works in S. Francesco of Arezzo, *The Discovery of the Wood of the True Cross*. These show not only Piero's advanced knowledge of perspective and mastery of colour, achieving almost luminous effects as never before in fresco painting, but also his geometric orderliness and skill in pictorial construction.

With his innovations he paved the way for the High Renaissance. From 1469 mention was made of him at the court of the Montefeltre in Urbino, where he came into contact with Dutch art. Already celebrated in his life-time, Piero was greatly influential in northern Italian art in the second half of the 15th century. Later, he also set down his theoretical ideas in writing.

Piero's *Baptism of Christ* was originally painted as an altarpiece for a church, demolished in the 19th century, in the town of Borgo Sansepolcro. It was subsequently incorporated into a triptych on an altar in the town's cathedral, flanked by two outer wings –

still housed in the cathedral today – by the Sienese artist Matteo di Giovanni. In contrast to contemporary works of Florentine painting, the landscape is rich and differentiated in design and flooded with light. Piero here continues along the path signposted by Domenico Veneziano in the St Lucy altarpiece. In his figural style, Piero thereby begins to move away from the ideals of the Florentine Early Renaissance. He is no longer quite so interested in establishing the three-dimensional solidity of his characters, for all their powerful modelling; outlines have become noticeably simpler, and so too the details of the draperies.

The landscape reveals Piero as a master of spatial depth, as evidenced in the river Jordan winding its way into the background and mirroring the landscape around it. At the same time, however, Piero honours the shallowness of the plane in the relief-like arrangement of his characters, whereby the grouping of two figures at right angles to each other plays an important role. The constellation of Christ and the tree, and the planimetric superimposition of Christ, the baptism bowl, John's hand, the dove and the tree-top, also serve to emphasize the flatness of the pictorial plane. The angels have been linked to the caryatids on the Acropolis, but Piero could not have known these at first hand.

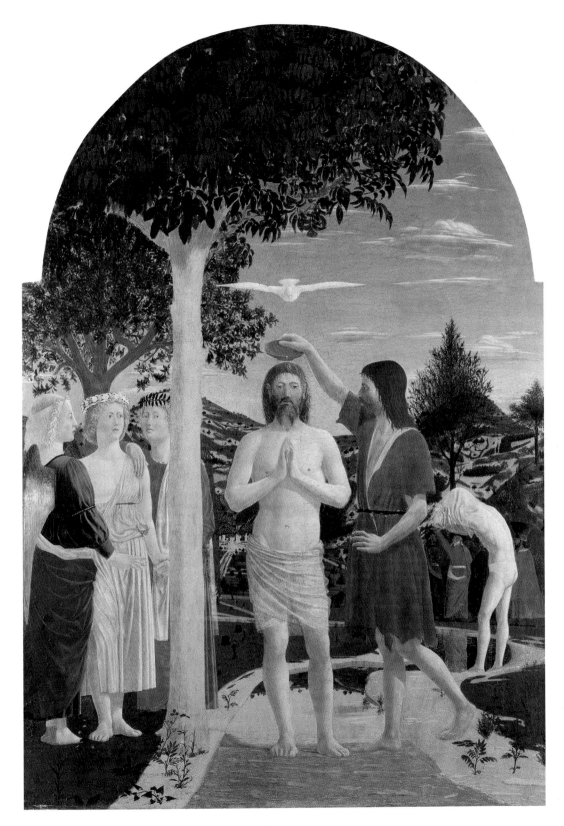

st ɹerome in his study

Tempera on wood, 46 x 36 cm
London, National Gallery

* c. 1430 Messina
† 1479 Messina

Antonello was born c. 1430 in Messina where he studied under local artists. His creative talent developed and found direction during his years of travel which took him as far as northern Italy. He probably worked in Naples around 1450. Here, the young painter was able to study major works of the Netherlandish school of painting, as King Alfonso I possessed a good collection of paintings by Jan van Eyck and Rogier van der Weyden.

It is also thought that the painter Niccolò Antonio Colantonio, (born c. 1420) who had studied the art of the Netherlands, taught Antonello in Naples. It was in this environment that Antonello discovered his talent for fine detail, whose textual reality is achieved by adding oil as binder, thus allowing the application of several transparent coats of colour. Learning about artistic devices employed in the Netherlands was so important that Vasari later, in the mid-16th century, assumed that Antonello must have visited Flanders, studying under Jan van Eyck (which in terms of time alone could not have been the case).

On his northern travels Antonello met Piero della Francesca in Urbino, whose works taught him the art of perspective and clear geometric disposition of space. With this combination of talents unique in 15th-century Italian painting, he reached Venice in 1475 where he stayed until 1476. His arrival must have been a revelation to the Venetian painters. He acted as catalyst, helping Venetian art to come into its own: colour modulation instead of the hitherto predominant outline. Because of this function, and the equally important one of mediator between north and south, Antonello is regarded as one of the most important figures in early Renaissance painting.

This small panel, executed after Antonello's departure from Messina, shows his close dependence upon Netherlandish painting. In its virtuoso mastery of foreshortening, however, it at the same time demonstrates the artist's assimilation of the achievements of the Early Renaissance.

The painted arch which frames the scene is a motif taken from Flemish painting and particularly familiar since Rogier van der Weyden. Gothic architectural elements and small details from the world of the still life – the bowl on the front step, the floor tiles, the view of the landscape beyond – also point to a study of Netherlandish artists. It was above all his adaptation of a Netherlandish oil technique, however, which enabled Antonello to achieve an effect previously unknown in Italy. By increasing the proportion of oil in his tempera, he was able to apply several layers of paint, or glazes, on top of each other and thereby to lend depth and luminosity to his colours.

Antonello's panel nevertheless differs from contemporary Netherlandish works in the disposition of the study, inserted like a monument into the architectural framework, and in its incorporation of numerous carefully calculated views in what almost amounts to a demonstration of the different possibilities of perspective.

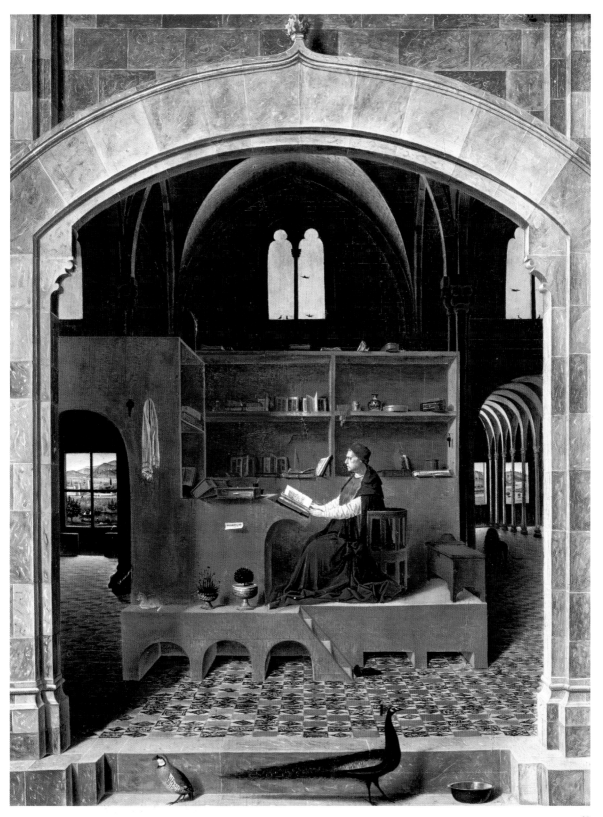

adoration in the forest

Tempera on poplar, 126.7 x 115.3 cm
Berlin, Staatliche Museen zu Berlin – Preussischer Kulturbesitz, Gemäldegalerie

* c. 1406 Florence
† 1469 Spoleto

Lippi is one of the most important successors to Masaccio. In 1421 he entered the monastery of Santa Maria del Carmine in Florence and was able to observe the decorative work in progress in the Brancacci Chapel. He used this experience in his first work, the frescos in the cloisters of the monastery (1432), now only surviving in fragments, with their plastic figures and individual facial expressions. His *Madonna of Tarquinia*, 1437 (Rome, Galleria Nazionale), is in her clear articulation reminiscent of Masaccio's altarpiece in Pisa. In the 1440s, complex movements and a restless treatment of drapery are discernible (*Annunciation*, Florence, San Lorenzo). These were the elements on which his great pupil Botticelli informed himself. With the decoration of the cathedral choir in Prato between 1452 and 1465, his artistic development reached its culmination, ranking him with Fra Angelico among the most outstanding fresco painters of his time. Lippi was chaplain to Santa Margherita in Prato from 1456, but he had to leave the order as he had formed a relationship with the nun Lucretia Buti, who bore him a son, Filippino (born about 1457), who as a pupil and assistant of Botticelli was to give the latter's late style certain Mannerist features. In his own late period Lippi painted various versions of the *Adoration of the Child*, the most famous being the one produced for the house chapel of the Palazzo Medici (now in Berlin, Gemäldegalerie). With its fairy-tale atmosphere created by light and shade, the rich use of gold and the magnificent flower carpet, this panel represents one of the finest achievements of the period.

As in the vision of St Bridget, Mary is kneeling in worship before her newborn infant lying naked on the ground – but without stable or cave, Joseph or shepherds, ox or ass. The fact that the scene is being contemplated instead by the young, dreamy-eyed John the Baptist and Bernard of Clairvaux suggests that this is no narrative painting, but a devotional picture in the most literal sense. The out-moded formulae employed for the landscape are disguised by the fantastical, deep forest. It has a fairy-tale atmosphere, but contains a very serious call to conversion: in line with the words of John the Baptist, the Kingdom of God is nigh and the axe laid to the tree – the artist-monk has even signed his name on it.

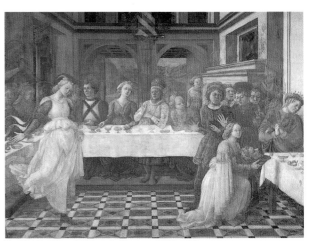

The Feast of Herod. Salome's Dance, c. 1460–1464

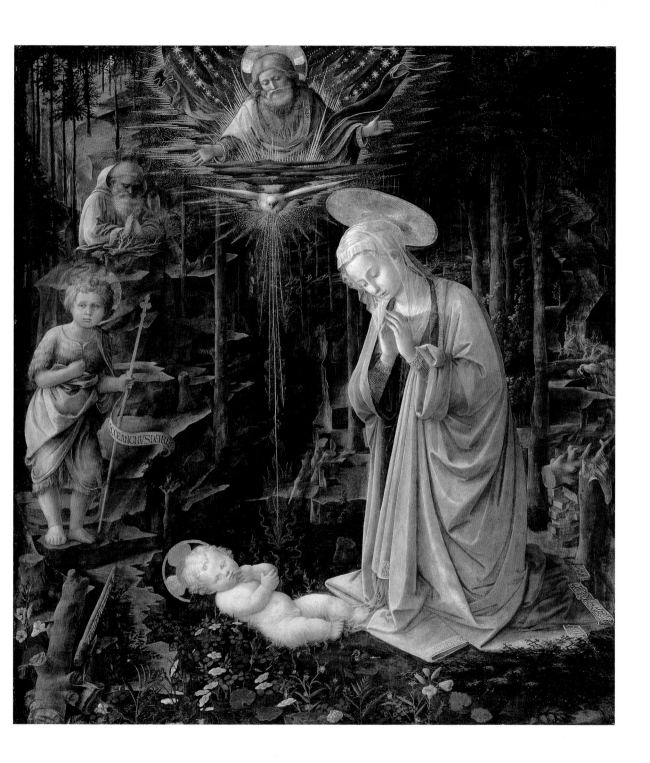

La Primavera

Tempera on wood, 203 x 314 cm
Florenz, Galleria degli Uffizi

* 1445 Florence
† 1510 Florence

After an apprenticeship as a goldsmith, which was to influence his entire work, he became the pupil of Filippo Lippi from whom he took over the Madonna and angel figures, but giving them more expression. There is no proof that he worked under Verrocchio, though this is probable for stylistic reasons. There he would have perfected his talent as master of the sensitively drawn line. His early work takes up the plastic realism of the past generation: the *Adoration of the Magi* (Florence, Uffizi, c. 1475) is characteristic with its clear composition, three-dimensional figures, strong, bright colours and individual treatment of the faces (Medici portraits). Later, the interest in space and physical form diminishes in favour of the richly moving line of slender figures and fine detail of jewels and richly embroidered dress (*Birth of Venus*, *Primavera*). But as his three frescos begun in 1481 on the lower wall of the Sistine Chapel show, Botticelli was well able to achieve monumental effects. He soon became a master of the large format: in his *Cleansing Sacrifice of the Lepers* the centre emerges naturally, the multi-figured groups connect, giving unity to the scene, and foreground, middle ground and background merge into each other. In his late work the line gains in sensitivity (92 silverpoint drawings for Dante's Divine Comedy) and in emotional expressiveness (*Annunciation*, Florence, Uffizi, 1490–1495). The religious fervour depicted in these later works may have been the result of Savonarola's sermons calling for repentance, but this tendency was already noticeable in his mature work. With his death in 1510 the 15th-century period of Italian painting came to a close.

Probably executed in 1477/78 for Pierfrancesco de' Medici's villa in Castello, this panel combines a monumental format (including life-size figures) with a technique reminiscent of miniature painting. Like the Birth of Venus, it testifies to the change in artistic thinking which took place in Florence after 1450. While the literature of classical antiquity continued to provide a source of thematic inspiration, its formal influence became virtually insignificant.

The encoded content of the Primavera can be unravelled with the help of a poem by Angelo Poliziano, who himself drew upon Ovid. The figure standing in the centre is Flora; on the far left, Mercury is scattering fog, while on the far right a wind god is chasing a fleeing nymph. Perspective and anatomy are no longer central themes of the composition, which is dominated instead by a sensitive handling of line and elongated proportions. The pale figures, some dressed in transparent robes, stand out against the dark background. In contrast to the strong colours which characterized the early years of the century, Botticelli's palette is restrained and muted. Where he appears to cite classical motifs, as in the case of the Three Graces on the left, he draws not upon antiquity directly, but on Ghiberti's bronze doors for the Baptistery in Florence (specifically, upon the group of serving maids in the relief of Jacob and Esau).

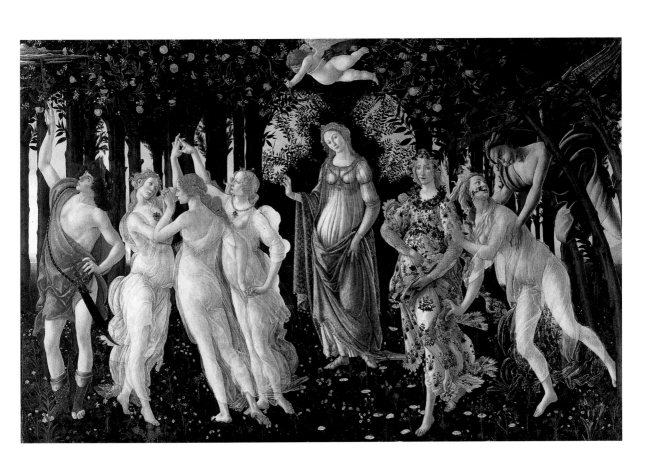

Dead christ

Tempera on canvas, 66 x 81 cm
Milan, Pinacoteca di Brera

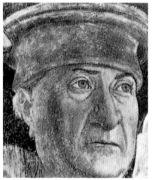

* 1431 Isola di Carturo (near Padua)
† 1506 Mantua

Together with Giovanni Bellini, albeit with different artistic aims, Mantegna was largely responsible for spreading the ideas of Early Renaissance painting in northern Italy. He studied in Padua under Francesco Squarcione, who also collected and sold antiquities and coins, thus introducing his pupil to this field. But most important for Mantegna's artistic development was the sculptor Donatello, who from 1443 created the high altar for San Antonio in Padua. From him he learned how to paint anatomically correct figures, how to achieve precision when tracing details, and not least how to compose a picture with accurate perspective. By 1448 the young painter showed himself almost independent in style when decorating the Ovetary Chapel of the Eremitani Church in Padua (most of it destroyed in World War II). In 1460 Mantegna became court painter to the Gonzaga family in Mantua. There he painted the frescos of the Camera degli Sposi in the Castello, whose illusionistic ceiling painting and other elements point forward to the structural problems of Mannerism and the Baroque. In about 1490 Mantegna began to produce engravings of great artistic and technical perfection which contributed greatly to the dissemination of Early Renaissance innovations north of the Alps.

Already famed in the 16th century as the *Cristo in scurto*, this painting was for a long time admired first and foremost for its extraordinary display of perspective virtuosity. And indeed, a figure presented in drastic foreshortening had never before been seen in Western painting. If we compare this dead Christ with the nearest of the disciples in the panel above, we can see the extent to which Mantegna had perfected his artistic skills. The two works would appear to be separated by almost a whole generation.

To concentrate solely on the technical mastery exhibited in the Dead Christ would be to miss its expressive content, however. The wounds seen from above in Christ's hands and feet, the helplessness suggested by his foreshortened upper body, and our oblique view of his slightly tilted head give visual expression to the finality of death in a previously unknown manner. The palette, which borders on grisaille, reinforces the impression of desolation. The composition seems to exclude all hope of a Resurrection.

The figures of Mary and John, sliced by the edge of the canvas, are painted in a surprisingly coarse fashion and appear clumsily inserted into the scene. Could it be that they were added at a later date?

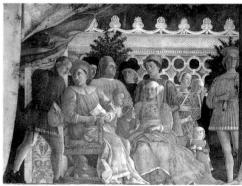

The Gonzaga Family, completed 1474

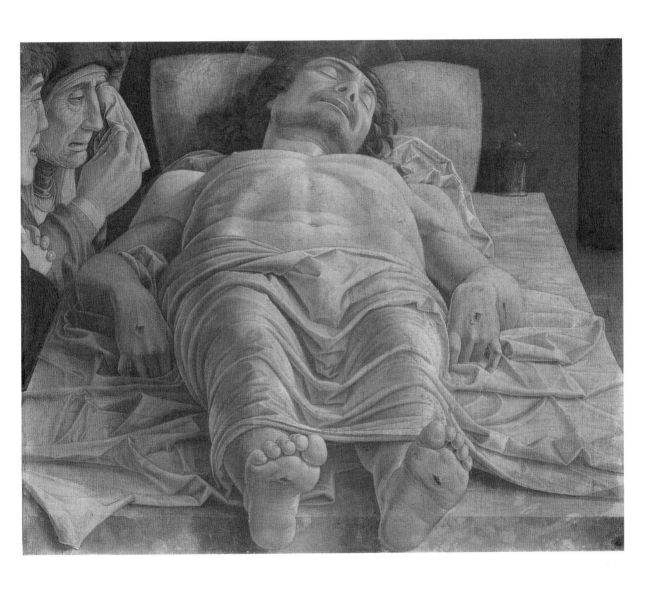

old man and young

Tempera on wood, 62 x 46 cm
Paris, Musée du Louvre

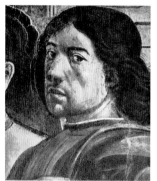

* 1449 Florence
† 1494 Florence

Ghirlandaio was the antithesis to Botticelli in Florentine painting of the second half of the 15th century. Botticelli's refined, courtly art stands in juxtaposition to Ghirlandaio's depiction of the prosperous middle class, where love of detail is dominated by brilliantly marshalled mass scenes. In his lavishly decorated "contemporary" architecture and distant landscapes, Ghirlandaio owed more to the traditions of the first half of the century. Above all, he is the one painter of his generation in Florence to have been destined for large-scale work, and therefore a born fresco painter. Already in 1481 he was one of the circle of selected artists to paint the lower half of the Sistine Chapel. His second major work was the decoration of the private chapel of the Sassetti family at Santa Trinità in Florence from 1483 to 1485. Scenes from the Life of St Francis were given the setting of 15th-century Florence, and even now some of his views of the city are of particular value as a historical source. Ghirlandaio told his stories in a lively manner, easily grasped by the imagination. Some details, such as figure arrangement, point to a Dutch influence, as demonstrated by his altar picture in the Sassetti chapel. The *Last Supper* fresco in the refectory of Ognissanti painted in 1480, a subject he used again in San Marco, was important in the way Ghirlandaio succeeded in bringing actual architecture into the scene. His creativity reached its culmination with his work in the main choir of Santa Maria Novella (1485–1490).

This panel occupies a special position in Florentine portraiture of the Early Renaissance. Never before in the name of realism had such careful attention been paid to ugly, even disfiguring detail. From here the path lay clear to the physiognomical studies by Leonardo, who also sought to record abnormalities. Both artists reflect the enduring influence of the *Portinari Altar*; only by looking closely at the heads of Hugo van der Goes' kneeling shepherds can we begin to understand Ghirlandaio's portrait. Although a slight questionmark still hovers over the attribution of this panel, a number of features link it closely to Ghirlandaio's late work. His frescos for the choir of Santa Maria Novella include numerous portrait busts of elderly men which similarly make no attempt to idealize the characteristics of old age. The head of the child, too, with his gleaming hair heightened with gold, recalls the heads of youths in other panels by Ghirlandaio. The relationship between grandfather and grandson is vividly brought to life in the kindly, thoughtful expression worn by the old man and the trusting, beseeching look in the child's eyes. In its precise detailing of every element, yet its deliberately unspecified location, the landscape falls fully in line with Florentine tradition. In the contrast between the solid wall and the view through the window, the artist may be referring on the one hand to the old life that is almost over, and on the other to the young life with so much before it.

"domenico di tommaso del ghirlandaio, who can be called one of the principal artists and one of the most excellent masters of his age because of the merits, grandeur, and multitude of his works, was created by nature herself to become a painter, and thus, notwithstanding the contrary wishes of his guardian, achieving great honour and profit both for art and for his family, and he was beloved in his own time."

Giorgio Vasari

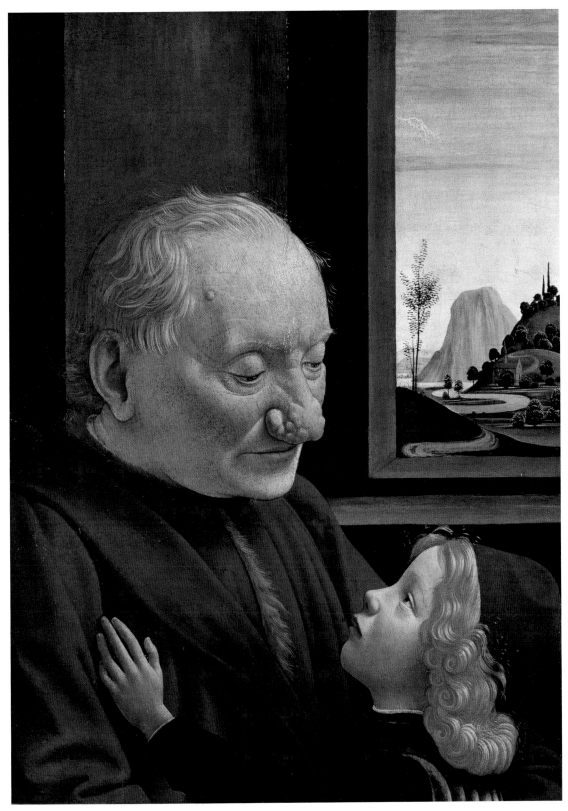

scene from the Life of st ursula

Tempera on canvas, 281 x 307 cm
Venice, Galleria dell'Accademia

* c. 1455 (1465 ?) Venice (?)
† 1526 Venice

Carpaccio was the principal pupil of Gentile Bellini. In his workshop he learned the precise observation of detail, the "staging" of multi-figured historical scenes and the composition of large-scale paintings. Artistically, however, teacher and pupil differed widely. While Bellini can be considered the "chronicler" of Venice in the late 15th century, Carpaccio was the born "novelist", intermingling freely what was actually before his eyes with his own inventions or with the material of legends. At a higher level he could be called the Benozzo Gozzoli of Venetian art. If Bellini's panels of the *Legend of the True Cross* can only be imagined in their large format, it is possible to see Carpaccio's efforts as book illustrations. This impression is reinforced by his choice of colours, sometimes bordering on pastel shades, as opposed to his teacher's adherence to those colours which are typically associated with the subject matter.

Carpaccio created all his major works for Venice: one of the earliest consisted of nine large panels depicting scenes from the legend of St Ursula; from 1502 to 1507 followed the scenes from the *Lives of Saints George and Jerome* for the Scuola di San Giorgio degli Schiavoni. A great number of panel pictures, mostly of religious content, are to be found in collections all over Europe. His mode of telling a story still belongs to the Early Renaissance, but in his brilliant rendering of the light and atmosphere of landscape and interiors, as well as in his handling of perspective, Carpaccio is already abreast of the innovations of the late work of Giovanni Bellini.

Alongside Hans Memling's *Martyrdom of St Ursula*, the nine large canvases which Carpaccio executed for the confraternity of St Ursula in Venice represent the most detailed treatment of the legend of St Ursula in Early Renaissance painting. Carpaccio's approach to history painting is directly related to that of his teacher Gentile Bellini, although without the absolute fidelity to background setting and architecture. While Bellini painted his native city of Venice, Carpaccio had to portray the various stops along the pilgrimage from England to Rome made by St Ursula and her betrothed, none of which he knew at first hand. Although the present scene, in which the couple are met by the Pope, takes place against the backdrop of the Castel Sant'Angelo, the latter is set amidst the hills of the Venetian mainland. The artist would have seen the castle in drawings or engravings of Roman monuments.

Carpaccio creates order within his large canvas using similar compositional means as his teacher: the main group of figures in the foreground, aligned parallel to the plane, is bounded to the left and right by other groups leading into the background. The solid block of the Castel Sant'Angelo is linked to the foreground by the row of flags, which simultaneously connect the front and rear, top and bottom of the canvas. In contrast to the severe style of Bellini the painter-chronicler, Carpaccio treats details with an imaginative flair and employs a cheerful palette.

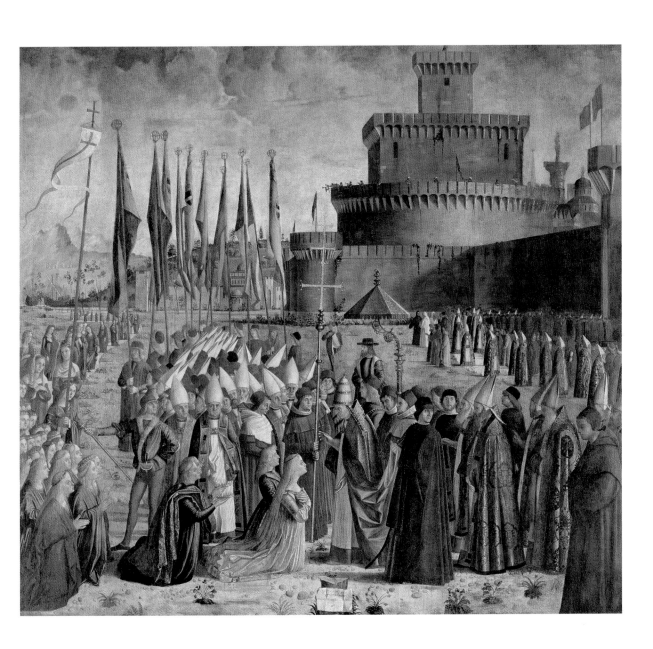

тhe рamned cast into нell

Fresco (detail), total width c. 670 cm
Orvieto, cathedral, Cappella di San Brizio

* c. 1450 Cortona
† 1523 Cortona

Born in the borderland between Tuscany and Umbria, it is likely that Signorelli received his artistically formative training in Florence, where he would have come under the influence of Florentine sculpture, particularly bronze casts. He probably studied under Pollaiuolo and Verrocchio for some years. Signorelli's special interest was the human figure in action. One of the main concerns of Florentine painting of the early 15th century had been the plastic, convincing rendering of the human body on the flat canvas, and this theme was taken up again by Signorelli; no longer, however, in an endeavour to depict three-dimensional forms, but rather to record exact details. His religious and secular subjects demonstrate his mastery in this field. Already in 1481 he was one of the artists chosen to participate in the fresco cycle below the window area in the Sistine Chapel (amongst others, Botticelli, Ghirlandaio and Perugino were engaged in this work). Piero della Francesca's influence on Signorelli should not be over-emphasised. Although his tendency to abstract composition (*Virgin and Saints*, Perugia, Domopera, 1484) and his handling of lighting effects may have been influenced by Piero, Signorelli's intention was not to create an atmosphere flooded with light, but to use strong light and deep shadow to model the forms of the body. Signorelli reached the height of his development with his frescos depicting the *Last Judgement* in Orvieto cathedral (1499–1504).

Fra Angelico and Benozzo Gozzoli had originally started decorating the San Brizio Chapel in 1447, but the commission was only revived at the end of the century. Signorelli here reaches the peak of his development, with a portrayal of the Last Judgement and the story of the Antichrist on a scale more ambitious than any previously seen in Western painting. He reduces the landscape background to a bare minimum and concentrates on human figures in dramatic poses. Not until Michelangelo would the sculptural approach at the heart of Tuscan painting come so clearly to the fore as in this cycle.

Colour serves exclusively to describe objects and, more important still, to heighten their plastic qualities through contrasts of light and shade. Line is the chief means of composition, establishing hard contours and clear-cut silhouettes.

Signorelli displays an inexhaustible inventiveness in the positions and angles of his figures. While echoing the 14th-century *Last Judgement* reliefs on the façade of Orvieto cathedral, they are more closely related still to the genre of the small bronze emerging in the late 15th century. Signorelli's Orvieto frescos represent the most important forerunners of Michelangelo's *Last Judgement*.

> "ın the мadonna, the principal church of orvieto, he … painted all the scenes of the end of the world with bizarre and fantastic invention – angels, demons, ruins, earthquakes, fires, miracles of the Antichrist, and many other similar things besides, such as nudes, foreshortenings, and many beautiful figures; picturing the terror that there shall be on that last and awful day."
>
> **Giorgio Vasari**

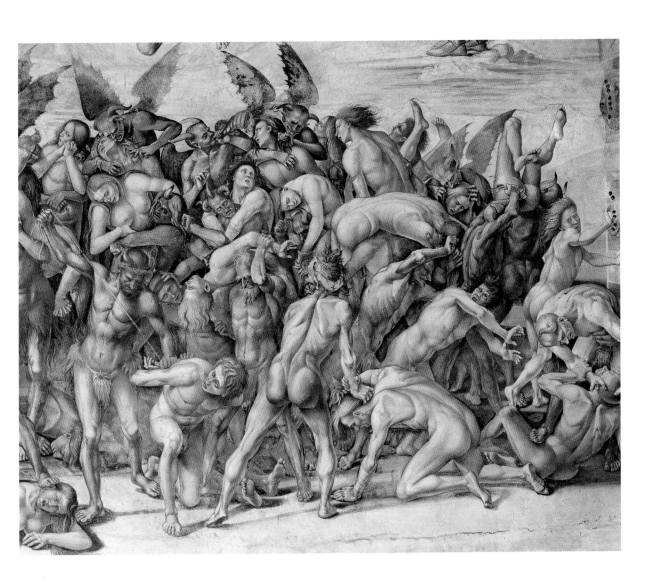

Portrait of Doge Leonardo Loredan

Tempera on wood, 62 x 45 cm
London, National Gallery

* c. 1430 Venice
† 1516 Venice

Giovanni was initially taught by his father Jacopo whose drawings of almost icon-like precision in the traditional 14th-century method and manner influenced his early work. When Giovanni's sister Nicosia married Andrea Mantegna in 1453, close relations between Venice and Padua were established, and Giovanni began to explore the physical and spatial representation of the Early Renaissance. Under Mantegna's influence his style assumes temporarily a certain calligraphic precision. The visit of Antonello da Messina to Venice in 1475/76 seems to have liberated Giovanni's innermost talents. Without abandoning the rational structure and interaction of form and space, his colours gain in luminosity and depth; modulation of tone increasingly replaces the dividing outline, light floods the canvas. The landscape, as can be seen in many of his representations of the Virgin and Child and the Pietà, achieves a quality that marks Bellini as the most important Italian landscape painter of the Early Renaissance. His ability to endow his figures with an expression of quiet contemplation while fully conveying movement and human anatomy, remains a secret that raises him above all his contemporaries. The great works of his late art, in particular his portrayals of the Sacra Conversazione, already cross the border from Early to High Renaissance in the way artistic freedom and convention merge. As teacher of Giorgione and Titian, Giovanni, whom Dürer on his second visit to Venice from 1505 to 1507 still called the greatest painter of his time, was of immeasurable significance for Venetian art in the 16th century.

The new genre of portraiture taking root in Tuscan and Flemish painting in the early 1400s failed to establish itself in Venice to the same degree. Only in the late 15th century, not least under the influence of Antonello da Messina, was the freedom to paint the individual finally won.

This late work by Bellini, dating from the opening years of the 16th century, marks the high point reached by Venetian portraiture at the gateway from the Early to the High Renaissance. The artist demonstrates equal mastery in his treatment of physiognomical detail and of fabrics and decorative detail. Modelling arises exclusively from the interplay of light and shade. There is no attempt to employ conventional means of perspective; the fact that the doge's head is slightly turned is indicated by the strings falling from his hat.

Something of an icon-like quality lingers on in Bellini's portrait in the unspecified nature of the doge's setting, his appearance reminiscent of a marble bust, and his distant expression.

Christian Allegory, c. 1490

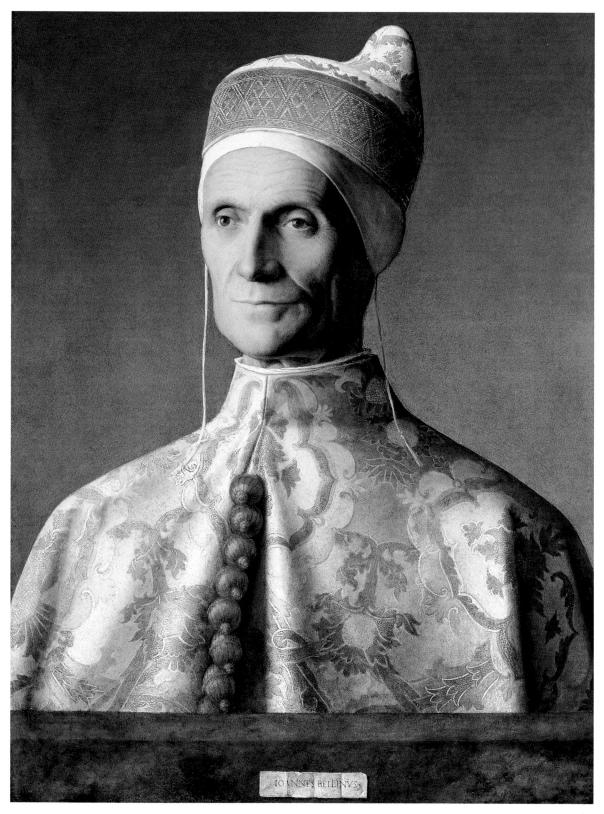

IOANNES BELLINVS

The virgin and child with St Anne

Oil on wood, 168.5 x 130 cm
Paris, Musée du Louvre

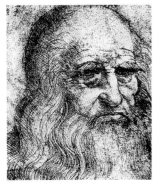

* 1452 Vinci (near Empoli, Tuscany)
† 1519 Cloux (near Amboise, Loire)

Leonardo was the embodiment of the Renaissance ideal of the universal man, the first artist to attain complete mastery of all branches of art. He was a painter, sculptor, architect and engineer besides being a scholar in the natural sciences, medicine and philosophy. He received his artistic training under Verrocchio in Florence, with whose workshop he retained contacts even after having become an independent master. He left Florence for Milan in 1482, working at the court of Duke Lodovico Sforza in the capacities of painter, sculptor and engineer until 1499. When the French invasion of the city caused the Duke to leave, Leonardo returned to his home ground, but worked again in Milan from 1506 to 1513. In 1513 he went to Rome, and in 1516, at the invitation of King Francis I, to France as court painter.

With his *Last Supper* in Milan Leonardo created the first work of the High Renaissance. His representation of the theme has become the epitome of all Last Supper compositions. Even Rembrandt, generally standing aloof from Italian art, was unable to resist its impact. Leonardo's work revolutionised both pictorial and painterly possibilities. While drawing had dominated over colour in the Early Renaissance, with Leonardo the outline was increasingly replaced by the use of mellowed colours which allowed one form to merge with another. Leonardo was never quite understood in Florence, but this was more than made up for by his influence on 16th-century Venetian art. His theories on art too were influential. He also supported his new ideas about painting with a sound theoretical basis. A number of projects remained uncompleted, such as the wall painting of the *Battle of Anghiari* in the Palazzo Vecchio in Florence, the numerous designs for the two equestrian monuments of Lodovico Sforza and Marshal Trivulzio in Milan, and also some architectural designs (Pavia cathedral).

Leonardo's *Virgin and St Anne* may be seen in several respects as the counterpart to Michelangelo's *Doni Tondo*. In both cases, three figures characterized by extremely complex and largely contrary movements are combined into a single group. But while Michelangelo is concerned above all with portraying the third dimension, Leonardo binds the gestures and poses of his figures into the geometric forms governing the composition.

Even more striking are the contrasts between the two artists' techniques. Whereas Michelangelo works primarily with line, leaving colour to play simply a descriptive role, Leonardo models both silhouettes and inner contours purely out of colour – in this respect already looking forward to the late works of Titian. He also employs colour to link the foreground figures with the fantastical landscape behind.

> "I think it is no small attraction in a painter to be able to give a pleasing air to his figures, and whoever is not naturally possessed of this grace may acquire it by study, as opportunity offers in the following manner: be on the watch to take good parts of many beautiful faces of which the beautiful parts are established by general repute rather than by your own judgement."

Leonardo da Vinci

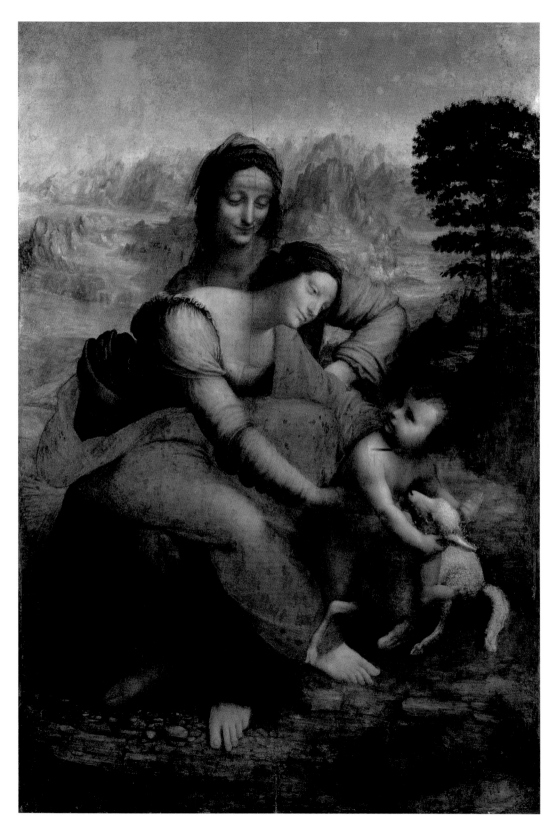

Rest on the Flight to Egypt

Oil tempera on wood, 69 x 51 cm
Berlin, Staatliche Museen zu Berlin – Preussischer Kulturbesitz, Gemäldegalerie

*** 1472 Kronach**
† 1553 Weimar

Lucas Sunder or Müller, who named himself after his Upper Franconian home town of Kronach, probably spent his first years of training in his father's workshop. Nothing is known about his further training and his years of travelling. There is evidence that he worked c. 1500–1504 in Vienna, making drawings for woodcuts and also painting. He had evidently studied Dürer's graphic art intensively. In his paintings, however, he showed at this time an imagination tending towards "romanticism", combined with an emotionalism heightened by colour – characteristics which formed the basis of his genius (*Crucifixion*, Vienna, Kunsthistorisches Museum, c. 1500; *Crucifixion*, Munich, Alte Pinakothek, 1503; *Resting on the Flight to Egypt*). In the works of this period, today regarded as the "true" Cranach, landscape and theme are brought to an atmospheric unity which must have impressed the young Altdorfer deeply. Cranach can be regarded as one of the founders of the Danube school. In 1504 he moved to Thuringia, following an invitation to become court painter to Frederick the Wise, and in 1505 settled permanently at Wittenberg. This concluded his first creative phase in which he produced his most important work belonging to the Dürer era.

This gave way to a completely new style for which the courtly climate must at least in part have been responsible. A visit to the Netherlands in 1508 brought him into contact with Dutch art and indirectly with the conventions of the Italian Renaissance. Cranach's love of fine detail increased at the same rate as his intellectual perception of construction, proportionally losing the rapt spontaneity of his early work. Cranach soon gained great esteem in Wittenberg. As a friend of Luther, he became the great portraitist during the Reformation without, however, committing himself to any particular confession. In the second quarter of the 16th century, while his workshop was flourishing, Cranach increasingly favoured a style tending towards the over-refined and Mannerist. This is especially noticeable in his depiction of the female nude, such as the panels of the Fall of Man and of Venus and Lucretia. This, too, may have been partly induced by courtly life with its predilection for erotic representation.

Executed shortly before the artist was appointed court painter at Wittenberg, the panel shows Lucas Cranach at the height of his creative powers. The composition combines clarity with uncoerced organization. The figures are grouped in a loose triangle whose vertical middle axis is accentuated by Joseph and the tree behind, but whose slightly offset position avoids any introduction of geometric rigidity. The backdrop of nearby trees on the left is harmoniously complemented by the unimpeded view of the distant landscape on the right.

Cranach demonstrates an astonishing freedom in the handling of his compositional means, whereby the dominant role played by colour modulation in the landscape evokes a romantic mood as characteristic of the Danube School.

Whether "Rest on the Flight to Egypt" is indeed an accurate title for this panel is a question that must remain open. Are we not in fact looking at a Holy Family surrounded by angels making music and playing games, their fairy-tale character echoed in the appearance of the landscape?

Whatever the case, Cranach includes neither a donkey nor baggage; the only indication that this might be a stop on a journey is the stick in Joseph's hand. The scene is set with the greatest candour in a mountainous southern German landscape.

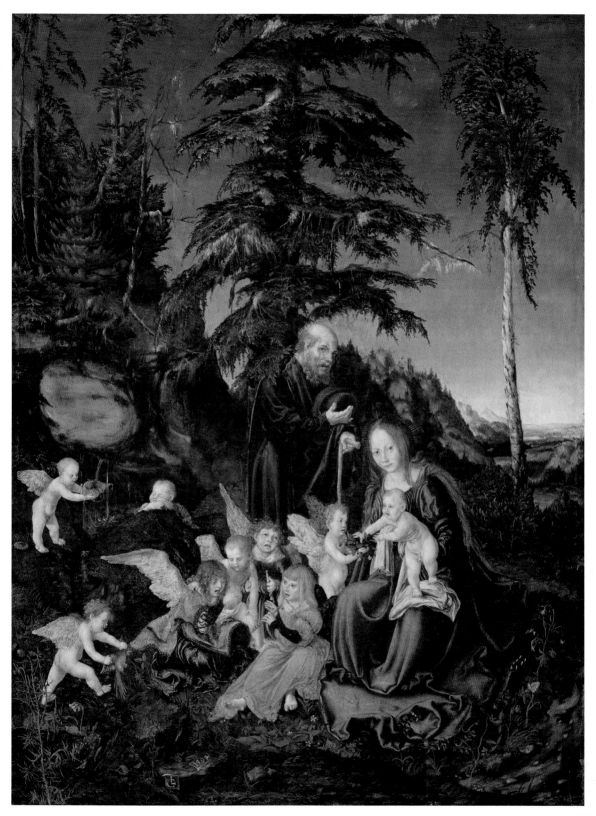

Delphic sibyl

Fresco, c. 350 x 380 cm
Rome, Vatican, Sistine Chapel

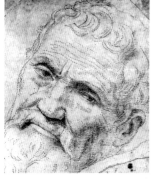

* 1475 Caprese (Tuscany)
† 1564 Rome

As Western art's giant of sculpture, no equal can be found for Michelangelo except in classical art. His painting as well as his architectural design was always based on plastic concepts. When aged thirteen, he was allowed to become an apprentice in the workshop of the painter Ghirlandaio, where he probably learned basic skills. Michelangelo greatly admired Giotto and Masaccio, as his early drawings after their works testify. Lorenzo de' Medici accepted the promising youth to work in the school in the Medici garden which contained a collection of classical sculptures. Michelangelo reinforced these early impressions while in Rome from 1496 to 1501. Here he created the *Pietà* for St Peter's, his only signed work. Returning to Florence, aged 25, he was next engaged on the colossal *David*. In this work he fully realised his perception of the human figure born in the spirit of antiquity, which filled his contemporaries with an uneasy reverence. Between 1501 and 1505 he also received his first painting commissions, including the only authenticated panel of the *Holy Family* (so-called *Doni-Tondo*). The fresco *Battle of Cascina*, of which detail drawings for the cartoon survive, was never executed. In 1505 Michelangelo was summoned to Rome by Pope Julius II to design his sepulchral monument – a gigantic venture which was thwarted by lack of finance and eventually by the Pope's death. Meanwhile the Pope had a new project in mind. In 1508 Julius asked Michelangelo to paint the ceiling of the Sistine Chapel. Michelangelo had completed this monumental task by 1512, after having done the work in two stages and under great pressure. As a painter he had produced his masterpiece with its great interpretation of Gene-

sis, the whole concept being conveyed by the human figure and gesture alone. Michelangelo's subsequent works were also dominated by the human figure. In 1534 he finally settled in Rome. Required to paint the altar wall of the Sistine Chapel, he produced a second masterpiece, the *Last Judgement*, 1536–1541. He also painted the frescos for the Vatican's Capella Paolina of the *Martyrdom of St Peter* and the *Conversion of St Paul* (1542–1550). As distinct from all Last Judgement representations that had gone before, Michelangelo's rendering of the subject, which covers the entire altar wall (14.83 x 13.30 m), is a vision of the end of the human race in which the light of redemption cannot overcome the powers of darkness. In his later life Michelangelo devoted himself increasingly to architectural projects. In 1546 he directed the building of the Palazzo Farnese and began the design of Capitol Square. A year later he was made chief architect of St Peter's. With his design for the dome he gave the Eternal City its distinctive landmark.

In his cycle of Sibyls and Prophets in the Sistine Chapel, Michelangelo undergoes a stylistic evolution which leads from the relief to the free-standing figure. Zechariah above the entrance wall and Jonah above the altar wall mark the two poles of this development, which goes hand in hand with an increase in the scale of the figures.

Although the *Delphic Sibyl* was painted during the first stage of the decoration of the Sistine ceiling, it already clearly reveals this trend towards increasing liberation from painted architecture. The Sibyl turns rightwards on her own bodily axis, while her left arm, holding the scroll, reaches across leftwards. A motif from the *Doni Tondo* is here used to indicate a more powerful crossing of space.

This effect is reinforced by the two putti in the background, who no longer stand side by side but at an oblique angle leading into the picture, thereby helping to release the figure from its architectural context. The relatively cool palette also lends the Sibyl the character of a painted marble sculpture. Never before had painting been so dominated by sculptural thinking as in Michelangelo's Sistine ceiling.

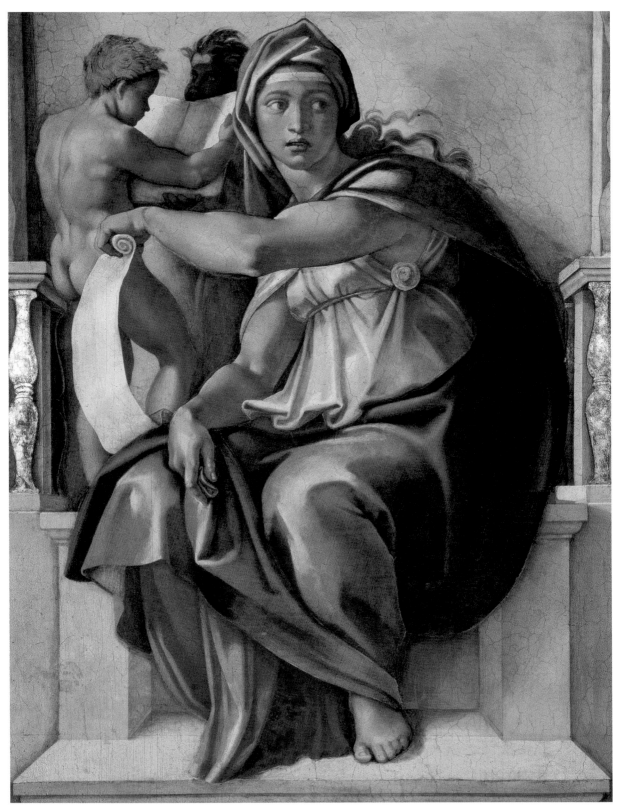

La Tempesta

Oil on canvas, 78 x 72 cm
Venice, Galleria dell'Accademia

* 1477 Castelfranco Veneto
† 1510 Venice

In the development of Venetian painting Giorgione's work provides the link between Giovanni Bellini and Titian. Giorgione was trained by Bellini, who also provided a decisive stimulus. Giorgione's *Madonna di Castelfranco* shows the influence of both Bellini and Antonello da Messina in its clarity of composition and richness of colour scale, while already revealing greater dynamism in the articulation of surface and less dependence on the drawing. In subsequent works, landscape gains in importance, by far exceeding Bellini's possibilities. The aim was not, however, to create "pure" landscape, as was the case north of the Alps with Dürer, Altdorfer and Wolf Huber. Giorgione's starting point was always the representation of the human being, whose moods and dreams are reflected in the landscape. But this was not the only way in which he achieved the fusion of figure and landscape; rather, it was done through acute sensitivity of colour aimed at producing the right atmospheric effect (*La Tempesta*; *Concert Champêtre*, perhaps completed by Titian; *Venus*, Dresden, Gemäldegalerie, c. 1505–1510). Giorgione's works are often mysterious in subject matter. He certainly exercised a lasting influence on the younger Titian with his soft modelling of forms in which line is replaced by colour. Giorgio Vasari stated with great admiration that Giorgione would put brush straight to canvas without preliminary sketch. Only a few of his paintings survive, although it isdifficult to identify those works that can be attributed to him with certainty. The versatility of histalent can be assessed only from the remaining frescos for the facade of the Fondaco dei Tedesci (Hall of the German Merchants in Venice, 1508). His most significant contribution was the representation of the figure in space, freely moving and fromall sides visible, and this idea was further developed by the great Venetian painters of the 16th century.

The allegorical meaning of the subject on the right has yet to be deciphered. It was described in around 1530 as a "Landscape on canvas with storm, gypsy woman and soldier". Efforts to interpret the painting were further complicated when X-rays revealed that the artist originally intended a second nude in place of the soldier, and that the work was executed in a number of stages – typical of the Venetian artist's spontaneous and emotional approach to the painting process, so different to that of his more reflective Florentine colleagues.

This is undoubtedly one of Giorgione's last works. The relationship between figure and landscape is developed in pronounced favour of the latter, colour modulation almost entirely replaces line, and the literary subject is of secondary interest. In this respect there is good justification for the painting's present title, which dates back to the 16th century: the representation of a natural event was certainly one of Giorgione's main concerns.

The fascinating way in which the artist dissolves fixed line into forcefully expressive colour, as seen in the soldier's clothing and the sky, for example, already looks beyond Titian's early work to the paintings of his mature years.

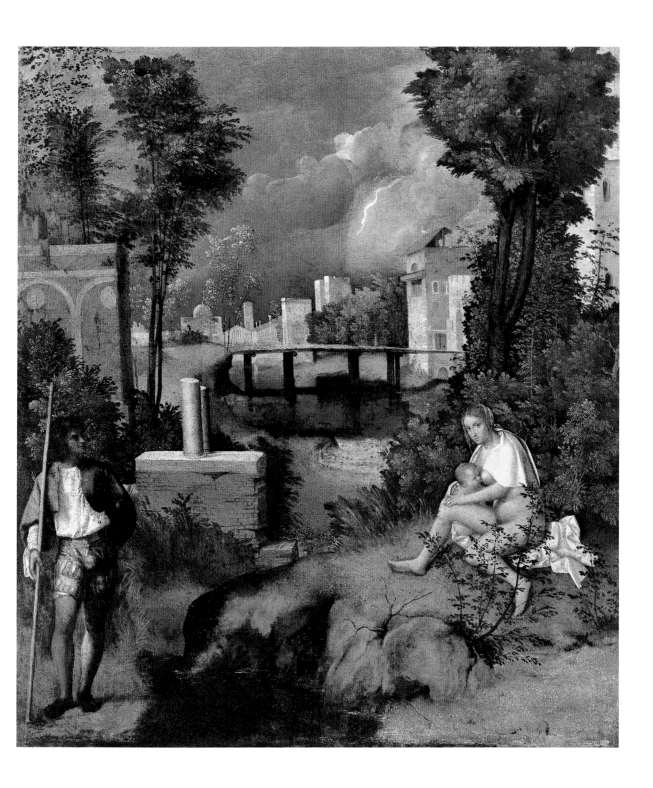

The Garden of Delights

Oil on wood, 220 x 389 cm
Madrid, Museo del Prado

*** c. 1450 's Hertogenbosch**
† 1516 's Hertogenbosch

Bosch is one of the great European painters of his time. The need to decodify his symbolic language, which is no longer generally accessible, although it is essential to an understanding of the spirit of the time, often deflects from the great artistic worth of his works. Bosch's training and early work remain largely in the dark. His attention to minute detail, which also characterises his large triptychs, has led to the assumption that he was trained as miniaturist. In the course of his development, Bosch increasingly refined his devices until he achieved a distinctive way of handling colour, combined with an equally distinctive clear outline. This marks him as a contemporary of Leonardo, whose works he may or may not have known. Bosch was, besides Geertgen tot Sint Jans, the great landscape painter in the Netherlands in the 15th and early 16th centuries. He gave the impetus to the development of the "world landscape" – such as by Patinir – and also of the autonomous landscape, such as Pieter Brueghel's *Seasons*. It is significant that Bosch, already highly regarded in his lifetime, should have found particular favour with his "morality" pictures in the very place where the 16th-century Inquisition had its worst excesses: in Spain.

Like the *Haywain triptych* (Madrid, Prado) and the *Last Judgement* (Vienna, Akademie der Bildenden Künste), the so-called *Garden of Delights* defies conventional iconographical categorization. *The Garden of Delights* is the largest, most complex and probably the last to be painted of Bosch's great triptychs and may be called his most important work. Its title dates right back to the 16th century: when it was brought to El Escorial on 3 July 1593, it was described as "una pintura de variedad del Mundo". The familiar world of Christian art is encountered only in the left-hand wing. In the foreground, God the Father unites Adam and Eve so that they may live in harmony with nature and all its creatures. The Garden of Eden is made up of gentle hills, meadows, hedges and a lake, and is populated by animals and plants, including a number of strikingly exotic varieties. Only the bizarre silhouettes of the rocky mountains in the background seem to point to the possible disruption of this peaceful co-existence.

Whatever the case, the central panel shows humankind giving itself entirely to the pleasures of the flesh, portrayed in inexhaustible variations which reveal themselves only upon closer inspection. In the middle ground we see a pond filled with bathers. Its circular shape is emphasized by a train of riders, almost all of them naked, processing in a ring around it. Is this the fountain of eternal youth, a popular subject of 16th-century painting, or a body of water in which the bathers want to cleanse themselves of their sins? In the right-hand wing, Bosch portrays the torments of Hell to which all of humankind is subjected. There are no just and no damned as in versions of the *Last Judgement*, but only sinners with no hope of salvation. Was Bosch, under the influence of the unrest in the Church and with a premonition that the centuries-old belief in the truth of salvation was about to collapse, giving vent to a profound sense of pessimism? Whatever the case, he paints a demonic, nightmarish world of torments beyond number. Despite being made up of many parts and small details, the underlying composition of the triptych is nevertheless carefully planned. Paradise and earth are linked by their bright palette and their landscape, sharing the same horizon. The slender stone form in the centre of the lake in the Garden of Eden also reappears in the middle panel – in five different variations. In conjunction with the circle of water and riders, these forms lend a certain degree of order to the initially seemingly impenetrable mass of figures. Hell, on the other hand, bears no relation to the other two panels; in this world of darkness, there is no hope of any glimmer of light.

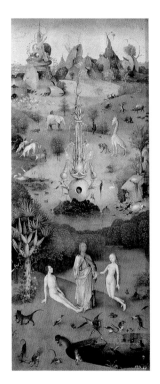

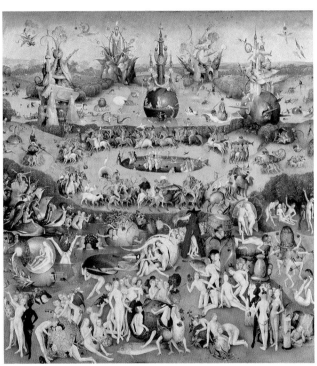

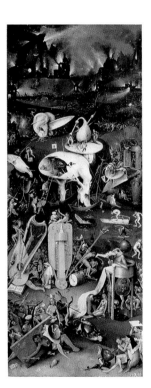

тhe Аdoration of the тrinity from the Landauer Аltar

Oil tempera on wood, 135.4 x 123.5 cm
Vienna, Kunsthistorisches Museum

==

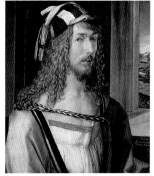

* 1471 Nuremberg
† 1528 Nuremberg

Dürer's work is often, and quite rightly, regarded as the quintessence of the spirit of German art. A master of the graphic arts as well as painting, Dürer, through his extraordinarily dynamic development, laid the foundations of the German High Renaissance. He was the most important mediator between Italian and German art. As the son of a Hungarian goldsmith who settled in Germany, he may well have learned his father's craft before entering the workshop of Nuremberg's leading painter, Michael Wolgemut, in 1486. In 1490 he went on tour through the south-western parts of the country, also visiting Basle and Colmar where he discovered that Schongauer, whom he admired and who had given him direction in his early work, was no longer alive. In 1494 he went to Venice for the first time. A year later he opened his own workshop in Nuremberg and became acquainted with a circle of humanists, one of whom, Willibald Pirckheimer, was to become a life-long friend. Graphic works featured largely in his early period. The linear design of his fifteen woodcuts of the *Apocalypse* achieved a height of expression never reached before. This was followed by sets of woodcuts entitled *The Great Passion* (1498–1500) and the *Life of Mary* (1501–1511). His second visit to Italy from 1505 to 1507, which again centred on Venice and where he studied in particular Giovanni Bellini, brought his development to maturity, making him one of the great European painters of the High Renaissance. Apart from a visit to the Netherlands (1520/21), Dürer remained in Nuremberg, highly esteemed and becoming a great supporter of the Reformation in the last decade of his life. There he produced his major

works (*The Adoration of the Trinity*, *Four Apostles*), also painting many portraits, including *Hieronymus Holzschuher*. His famous, so-called master engravings date from the period 1513/14. Dürer's watercolours depicting topographically accurate views represented a first step in the development of pure landscape painting. The extent of his surviving work is astounding: about 70 paintings, 350 woodcuts, 100 copper engravings, 900 drawings plus the watercolours. Dürer's influence on subsequent generations was immense. In the 19th century, when German "medieval" art was rediscovered, a veritable Dürer renaissance occured which often led to a falsified image of the artist.

Matthäus Landauer commissioned this panel for the Trinity chapel in the House of the Twelve Brethren which he had founded in Nuremberg in 1501. The institution was intended to provide accommodation for twelve elderly craftsmen who through no fault of their own had fallen upon hard times. A preliminary sketch showing the magnificent frame which originally contained the panel is dated 1508. Clearly, therefore, the commission had already been awarded by that time and the chief elements of the composition had already been planned. The original frame is today housed in the Germanisches Nationalmuseum in Nuremberg. The panel portrays the Holy Trinity – God the Father, Christ, and the dove of the Holy Ghost – being worshipped by the civitas dei (the inhabitants of the kingdom of God on earth). Both the subject and the composition recall Raphael's *Disputà* in the Stanza della Segnatura in the Vatican, which Dürer however could not have known, since it was only begun in 1509. Rather, Dürer's panel is part of an international trend towards "classical" form, albeit one inconceivable north of the Alps without the influence of Italy. The isolated treatment of individual elements in Dürer's earlier paintings is here overcome through the means of colour modulation and, above all, composition. In a similar fashion to Raphael, circular – i.e. geometric – and spherical – i.e. stereometric – segments mutually overlap. At the same time, the top, arched edge of the painting is incorporated into the internal composition.

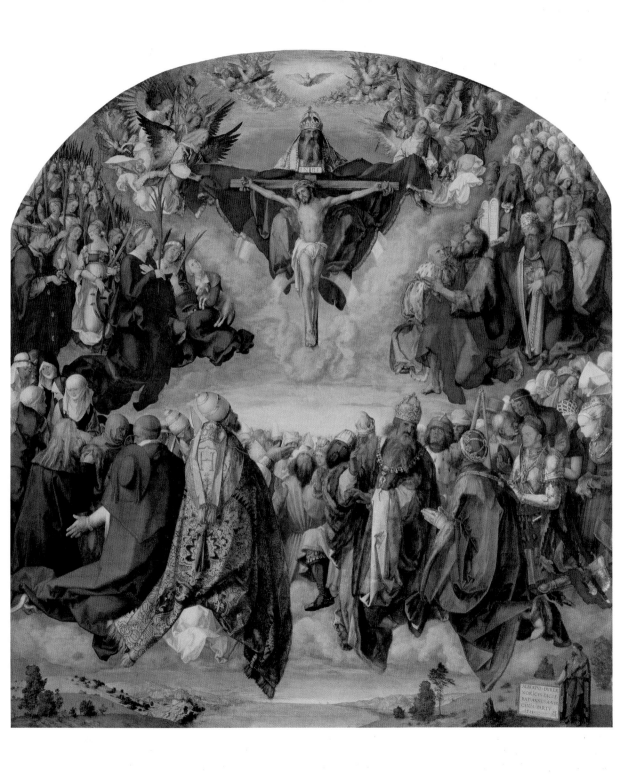

тhe crucifixion from the ısenheim Altar

Oil on wood, 269 x 307 cm
Colmar, Musée d'Underlinden

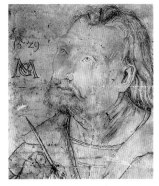

*** c. 1470/80 Würzburg (?)**
† 1528 Halle

Joachim von Sandrart entered this painter's name erroneously as Grünewald in his *Teutsche Akademie* (1675). His real name was Mathis Neithart or Nithart, and he later called himself Gothart. Grünewald is, beside Dürer, the most important representative of Northern painting at the turn of the 15th to the 16th century, and he is also Dürer's complete opposite. As Dürer's foremost artistic device was the line, so Grünewald's was colour, which he used to achieve new heights of expressiveness. And while Dürer turned to the new discoveries of the Renaissance in the course of his development, Grünewald generally continued to adhere to the Middle Ages. Tradition and "progress" cross each other in unexpected ways in the works of these two masters. And yet Grünewald was a man of the Renaissance in the way he lived and applied his many talents. In 1509 he became court painter to archbishop Uriel von Gemmingen at Aschaffenburg, and in this capacity he had to supervise the rebuilding of the palace there. In 1516 he started on a fixed income at the court of the elector Albrecht von Brandenburg where he worked as a painter and architect and also as a designer of fountains. He had to leave this post in 1520 because of his Lutheran convictions.

His major works include the *Isenheim Altar*, *The Mocking of Christ* and the *Erasmus-Mauritius* panel; two pictures of the *Crucifixion* (Basle, Kunstmuseum, 1505; Washington, National Gallery, c. 1520); four figures of saints in grisaille for the wings of Dürer's *Heller Altar* (Donaueschingen, Fürstliche Gemäldegalerie, and Frankfurt am Main, Städelsches Kunstinstitut, 1501–1512); the *Stuppach Madonna* (Stuppach, parish church) which formed part of the *Maria-Schnee-Altar* in Aschaffenburg (1517–1519), as did the *Founding of Santa Maria Maggiore* (Freiburg, Augustinermuseum); and the *Crucifixion* and *Christ Carrying the Cross* of the *Tauberbischofsheim Altar* (Karlsruhe, Kunsthalle, c. 1525).

The famous *Crucifixion* from the *Isenheim Altar* portrays the agony of Christ with a penetrating forcefulness seen neither before nor since. The tortured body, with its bowed head and skin almost grey in pallor, its strained sinews and muscles and its fingers seemingly frozen rigid in cramp, bears witness to Christ's suffering. The slight sag in the arms of the cross reinforces the impression that the body is hanging heavily downwards. The terrible nature of the scene is reflected in the stormy night landscape and the intense expressions and poses of the Virgin Mary, John and Mary Magdalene.

Unique in the expressive force of its poses and gestures, Grünewald's panel acquires its "overwhelming" character first and foremost from the eruptive power of colour and colour contrasts. None of the great German painters of Dürer's era matched Grünewald in evoking the emotions of the spectator through colour rather than through drawing.

> **"мatthaeus Grünewald, otherwise known as мatthaeus of Aschaffenburg, does not take second place among all the noble practitioners of the art of drawing or painting, but he is in truth to be set alongside the most excellent and best amongst them."**
>
> Joachim von Sandrart

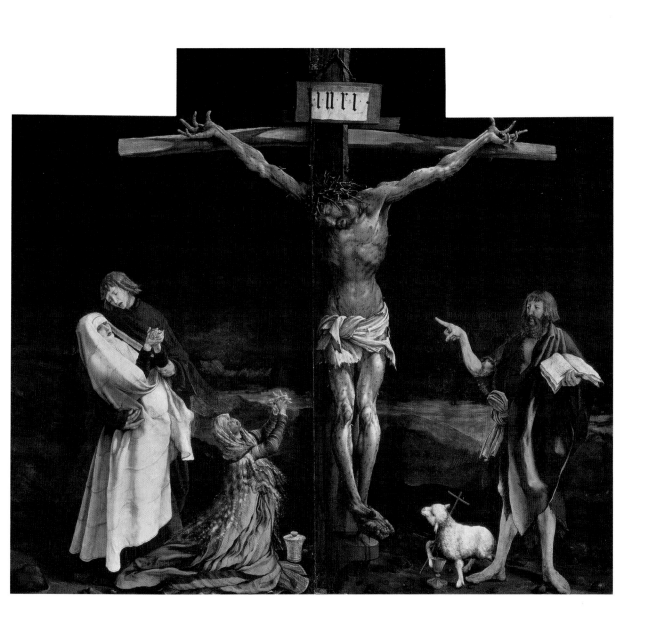

тhe тransfiguration

Oil on wood, 405 x 278 cm
Rome, Pinacoteca Vaticana

*** 1483 Urbino
† 1520 Rome**

Raphael's fame as the greatest painter of the Western world will continue despite certain detracting voices which made themselves heard at the beginnig of the 20th century. He began his apprenticeship with his father Giovanni, learning basic manual skills, but would have had greater artistic and educational benefits from the circle surrounding the court of Montefeltre. Fundamental to his development was his training under Perugino, whom he later assisted. Here Raphael learned the art of composition and gained the knowledge which enabled him to merge landscape and figure sensitively, and so develop the dreamy sensitivity of expression so characteristic of his work, particularly of his Madonnas. His move to Florence in 1504 at the age of 21 marked a decisive period in his stylistic development. Figure and space were at the heart of his learning.

Already in 1508 his fame began to spread when Pope Julius II called him to Rome for the decoration of apartments at the Vatican. His fellow-countryman Donato Bramante, who was engaged in the rebuilding of St Peter's, may have helped to secure this commission. His first large work in the Stanza della Segnatura (1509–1512) already shows his personal conception of design and form with figures combining statuesque dignity with freedom of movement. However, with his decoration of the Stanza d'Eliodoro (1512–1514) he achieved further heights in dramatic expression, suggestion of depth and colour modulation. Raphael crossed the border between High Renaissance and Mannerism as demonstrated in the large panel paintings of his late period (*Sistine Madonna*, Dresden, Gemäldegalerie, 1512/13; group portrait *Pope Leo X with Cardinals Giulio de' Medici and Luigi de' Rossi; Transfiguration*). The large number of commissions for fresco cycles (Loggias at the Vatican, Farnesina) and other works resulted in the organisation of a large workshop. His significance as an architect can now only be traced in outline. In 1514 he became chief architect of St Peter's; in 1515/16 he built the Palazzo Madama in Rome and designed the Palazzo Vidoni-Caffarelli, also in Rome (1515) as well as that of the Pandolfini in Florence (1517–1520).

Raphael's last work is a summation of his entire artistic development and at the same time heralds the dawn of a new age. He treats his subject in a new fashion. In the top half of the picture, the transfigured Christ appears between the prophets Moses and Elijah above the rocky summit of Mount Tabor. The frightened disciples have flung themselves onto the ground beneath Christ's feet. In the lower zone, an epileptic boy is being presented by his distraught parents to the disciples, who can do nothing. Two events related in the Gospels as occurring in chronological succession are here combined into a single scene: Christ is rendered visible in his divine form as the only one who can offer help, whereby salvation is made a certainty. Raphael further amplifies the distinction between the earthly and the heavenly zone. The sculptural modelling and powerful colour harmonies of the lower half of the painting offer a pronounced contrast to the less solid figures of the Transfiguration scene, united by their paler hues.

Raphael nevertheless succeeds in establishing a visual connection between the two halves. Top and bottom are linked by the overall circle into which the figures above and below are grouped, by the numerous upward-pointing gestures made by those below, and above all by the dynamic slant which rises from bottom left to top right in the shadow cast by the rocky cliff. Members of Raphael's workshop, and in particular Guilio Romano, would have been involved in the completion of the lower half of the painting.

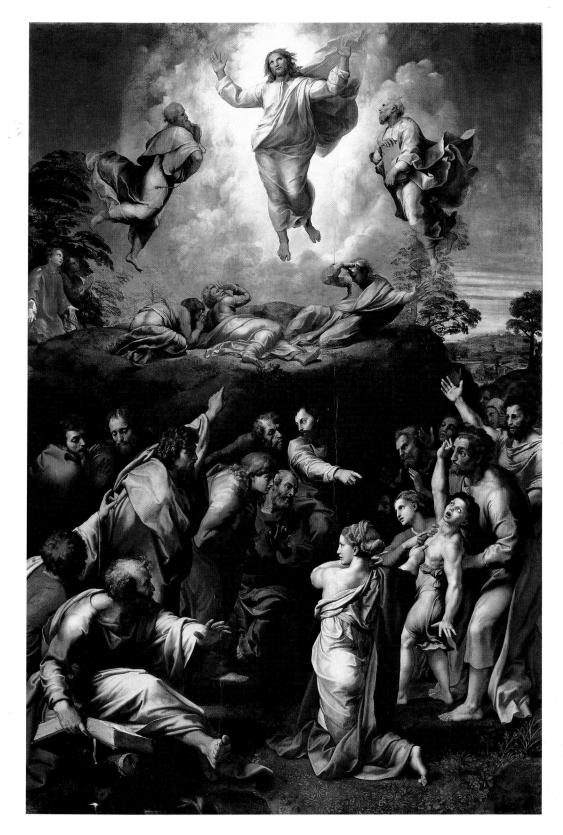

Bacchanalia (The Andrians)

Oil on canvas, 78 x 72 cm
Madrid, Museo del Prado

* c. 1488 Pieve di Cadore
(Venetia), † 1576 Venice

Titian was the most outstanding painter of the 16th century. At a time when Mannerist tendencies became prevalent, he took over the heritage of the High Renaissance and carried it further. Although the standards of "classical art" of about 1500 were his guideline, he endowed them with a new dynamism for greater effect. He played a unique role in the history of colour and found ways of achieving unprecedented freedom in pictorial composition, making him not only the most important precursor of European Baroque (Rubens), but also a lasting influence on painters until the late 19th century. Manet, for example, studied and copied his work in the Louvre.

Titian's training under Giovanni Bellini was decisive for his career. In his workshop he probably also worked with Giorgione, his senior by ten years. The artistic temperament of these two young painters was obviously closely related, because to this day their contributions are inseparable in some pictures. Titian's *Assumption of the Virgin* altarpiece in Santa Maria dei Frari in Venice (1516–1518) represented an important innovatory development in Venetian painting, both in composition and handling of colour. With this work, he had created an entirely new type of altarpiece which was to set a standard for the future, also in terms of dimension and the way it merged with the space of the building. It ushered in a "proto-Baroque" phase in Titian's development. His *Madonna with Saints and members of the Pesaro family* (1519–1528, also in Frari) represented a similar milestone in the "Sacra Conversazione" field. Apart from altarpieces

Titian painted religious pictures, mythological, poetical and allegorical subjects, and excelled as a portrait painter. The constant refinement of his painterly devices made the canvas his ideal medium, according the fresco a background role. Already in 1530 Titian had attained European eminence. In 1533 the Emperor Charles V called him to his court and made him a Count Palatine. But Titian never left Venice for very long. In his late work colour achieved an almost "Impressionistic" effect (*Annunciation*, Venice, San Salvatore, 1565; *Christ Crowned with Thorns*, Munich, Alte Pinakothek, c. 1570). By abandoning all outlines, he contrived to let air, light and colours unify the scene, so transcending earthly experience (*Pietà*, Venice, Accademia).

The subject and composition of the Bacchanalia recall Giovanni Bellini's *Feast of the Gods* of 1514. Compared with his teacher's work, Titian's canvas seeks to infuse a new dynamism into the movements of the revellers and into the ascending line traced from left to right by the landscape and figures and terminating in the sleeping old man on the hill on the far right. The sensuality of the – in part, unaffectedly naked – figures is also lent far more direct expression. Insofar as none of the characters seek eye contact with the viewer, the self-contained nature of the world within the picture is nevertheless maintained. The deliberation with which Titian approached his composition is demonstrated by, amongst other things, the variation upon the motif of Venus seen in the sleeping woman in the bottom right-hand foreground, who serves to consolidate the internal boundaries of the composition.

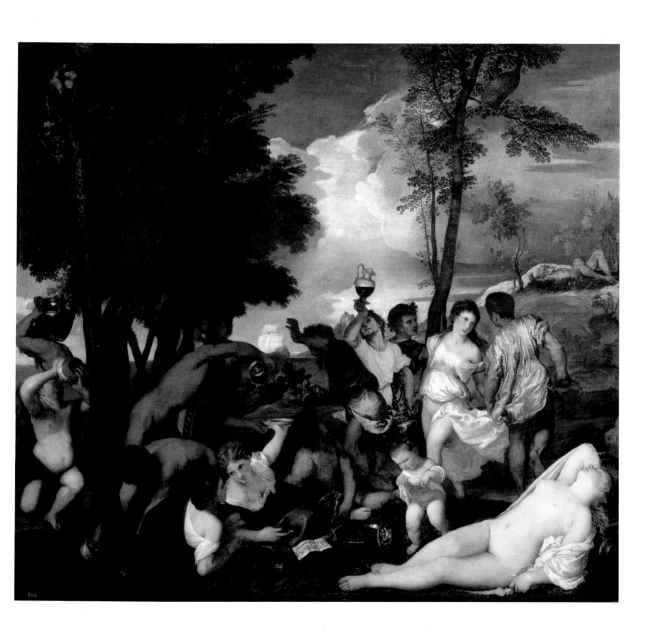

Deposition

Oil on wood, 313 x 192 cm
Florence, Santa Felicità, Cappella Bardori

* 1494 Pontormo (near Empoli)
† 1556 Florence

Pontormo can be regarded as one of the most interesting figures in 16th-century Italian art and also as an exponent of Florentine Mannerist painting. Like Rosso Fiorentino, a pupil of del Sarto, his early work still reflected the High Renaissance, apart from increased movement (fresco of the *Visitation* in the forecourt of Sant' Annunziata, Florence, 1514–1516). In subsequent years Pontormo abandoned this style, with its balanced composition, logical construction, idealised figure representation and clear coloration (*Sacra Conversazione*, Florence, San Michele in Visdomini, 1518). Pontormo's fresco cycle in the cloister of Certosa di Galluzzo near Florence, 1530, draws on an intensive study of Dürer's graphic art. Then, in the following period, Pontormo increasingly set out to portray movement in all its forms and directions (*Visitation*, Carmignano parish church, near Florence). By distortion of the ideal physical proportions – elongated figures with small heads – exaggerated perspective and use of relatively harsh, vivid colours, he transposed traditional pictorial themes into a new sphere in some respects related to medieval art. His late works, particularly in the rendering of figures, strongly reflect the influence of Michelangelo, whom he met around 1530 in Rome. A favourite of the Medici, he carried out much important fresco work, which has, however, not survived. Pontormo's portraits belong to the greatest achievements in this field in Florentine painting.

Like Rosso's panel, Pontormo's *Deposition* represents the pioneering vehicle of an anti-classical style of painting. Even the subject is difficult to determine: for a Deposition, it lacks a cross, for an Entombment a grave, and for a Pietà or Lamentation the direct relationship between the Virgin Mary and Christ. Painting, by its very nature, can normally only capture a single moment. Pontormo fascinatingly attempts to overcome this limitation and to portray instead a sequence of movements. It is as if we see the individual stages of a Deposition combining themselves into the suggestion of a continuous downward motion. The figures are grouped into a large, serpentine curve whose descending path is lent particular emphasis via the figure of the Virgin Mary and the falling diagonal in the bottom right-hand corner.

The composition is devoid of stabilizing elements, unstructured either by architecture or landscape. It might be described as a skilful fusion of "unstable equilibria". The transparent and modulating palette, undoubtedly influenced by Rosso, robs the figures of their gravitational weight and distances them from reality.

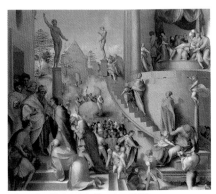

Joseph with Jacob in Egypt, c. 1515

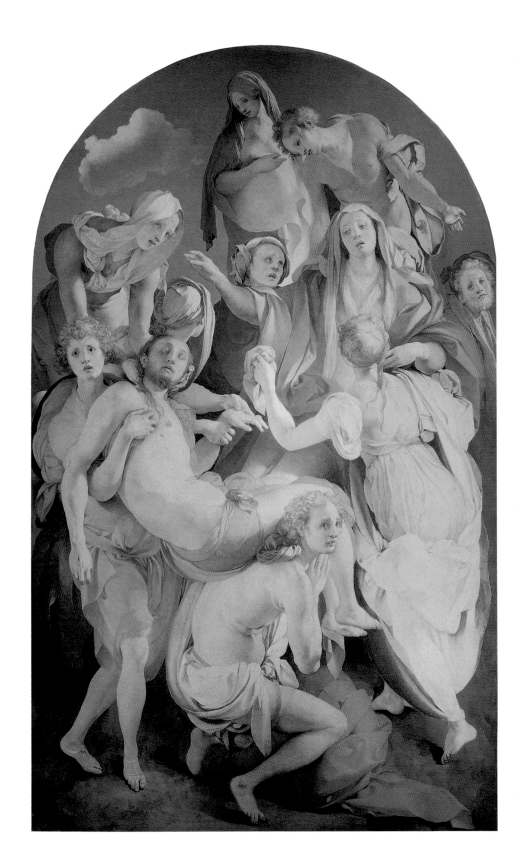

Alexander's victory (The Battle on the Issus)

Oil tempera on wood, 158.4 x 120.3 cm

Munich, Bayerische Staatsgemäldesammlungen, Alte Pinakothek

* c. 1480 Regensburg (?)
† 1538 Regensburg

Altdorfer is one of the most talented painters in the whole of German art. Although also a draughtsman and engraver, his importance lies in the field of coloured representation. Here, only Grünewald can be compared to him because all other contemporary painters were committed to the conventions of outline and drawing qualities. Altdorfer achieved, through his colour modulation, completely new ways of expression directed at the emotions. His tendency towards the "romantic" is particularly noticeable in his landscapes. Thus it was he who painted the first picture in European art that is purely a landscape (*Danube Landscape near Regensburg*, Munich, Alte Pinakothek, c. 1530), and in many of his other paintings figure and landscape merge in such a way that the scenic becomes background (*St George in the Forest*, Munich, Alte Pinakothek, 1510). Altdorfer, who travelled in the Alpine countries in 1510, became the leading light of the so-called "Danube School". There is no actual proof that he went to Italy. This seems highly probable, however, when looking at his virtuoso handling of spatial construction in the St Florian passion altar panels (after 1510). In his later work Altdorfer moves towards Mannerism in his complex depiction of moving elements, the daring approach to depth and new handling of colour.

Nothing is known about the painter's formative years and early beginnings. There is evidence that in 1505 he lived in Regensburg, where he bought property in 1513. His election to the town council in 1519 and to the inner council in 1526 shows his good standing. At the same time he served as civic architect. There is no information about his architectural work, but it is possible that he was involved in the design of the pilgrim church "Zur Schönen Madonna" (now the new Neupfarrkirche) at Regensburg.

No history painting had ever before attempted to suggest such a seemingly infinite number of soldiers and thereby to give the impression of a real battlefield. Altdorfer's talent as an artist lay not least in his ability to combine such a wealth of minutely-executed detail into a homogeneous composition. Most significant of all is the setting: from an elevated viewpoint, we look across a landscape which has been convincingly interpreted as a representation of the entire Mediterranean region. In the middle ground we see the eastern Mediterranean with Cyprus; beyond the isthmus the Red Sea; beside it on the right Egypt and the Nile, whose delta is accurately shown with seven arms; left the Persian Gulf; and in the needle-like mountain beneath, the Tower of Babylon.

In contrast to the fixed boundaries of High Renaissance space, Altdorfer here seeks to portray infinity in a "global landscape". His combination of precision of line with richness of colour modulation identifies him as one of the greatest masters in the history of German painting.

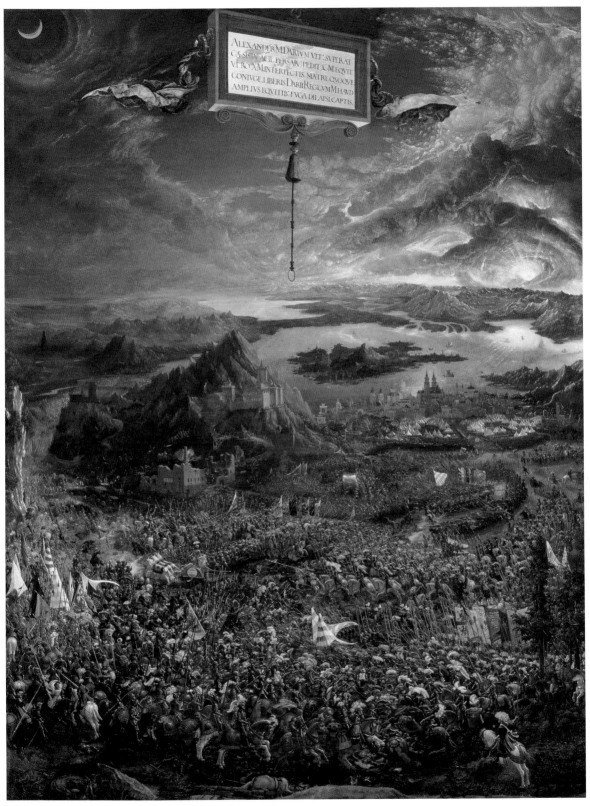

ALEXANDER M DARIVM VLT SVPERAT
CA SIS IN ACIE PERSAR PEDIT CM EQVIT
VERO AM INTERFECTIS MATRE QVOQVE
CONIVGE LIBERIS DARII REGCVM M HAVD
AMPLIVS EQVITIB FVGA DILAPSI CAPTIS

Portrait of a Lady as Lucretia

Oil on canvas, 96 x 111 cm
London, National Gallery

* c. 1480 Venice
† 1556 Loreto (Marches)

Lorenzo Lotto, one of the most important 16th-century Venetian painters, lived an unsettled life far away from his home town. He grew up in Venice under the influence of Giovanni Bellini and the works of Antonello da Messina before travelling in the Marches and being introduced to the works of Melozzo da Forlì and Signorelli. These sharpened his understanding of perspectival construction and precise presentation of human movement. His work in the Vatican (1509–1511), of which no traces remain, indicates early success which, however, did not endure. Although recognised while working in Bergamo from 1513 to 1525, his lack of success in Venice caused him to retire to the Marches in 1549. In his religious works Lotto abandoned traditional patterns of composition. He was also an outstanding portraitist.

According to Roman legend, Lucretia, who was the wife of Lucius Tarquinius Collatinus, was raped by the son of the Roman king – a dishonour which subsequently resulted in her suicide. The event is supposed to have precipitated the collapse of the Etruscan royal line (510 BC) and thus to have led to the founding of the Roman Republic.

In the 16th and 17th centuries Lucretia was frequently portrayed as a symbol of purity. Lotto presents us with the three-quarter view of a woman dressed in fine, richly trimmed clothes. Turned slightly away from the viewer, in her left hand she holds a drawing of the naked Lucretia about to stab herself in the heart. An inscription in Latin on the sheet on the table reads: "Following Lucretia's example, no dishonoured woman should continue to live."

In the exquisiteness of its palette, the painting ranks amongst Lotto's greatest works. While the subject's face follows on from the tradition of Giorgione, the contrast between her brightly lit shoulders and the richly gradated reds and greens of her dress is worthy of a Titian. The costly pendant suspended from the gold chain, its precious stones refracting the light, is virtually without equal in 16th-century Venetian painting.

Portrait of a Young Man, c. 1506–1508

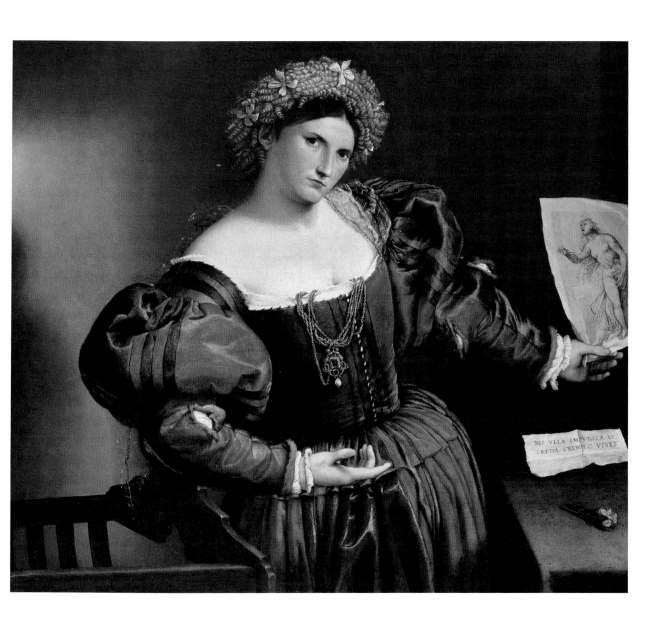

NEC VLLA IMPVDICA LV
CRETIA EXEMPLO VIVET

Family portrait

Oil on wood, 118 x 140 cm
Kassel, Staatliche Gemäldesammlung, Gemäldegalerie

* 1498 Heemskerk (near Haarlem)
† 1574 Haarlem

Heemskerck is one of the main representatives of the so-called Netherlandish Romanists. After training in Haarlem and Delft he entered the workshop of Jan van Scorel, only by a few years his senior, in 1527, probably working as his assistant rather than pupil. He visited Rome in 1532 and remained there probably until 1537. The exact archaeological precision of his drawings of ancient structures makes them highly valuable source documents on Roman monuments at the time. He was certainly back in Haarlem in 1538 as he received a commission for a winged altar with scenes of the Passion of Christ and the Legend of St Lawrence in that year. He soon acquired a high reputation as a painter of altarpieces and portraits. His contact with Haarlem humanist circles was reflected in his allegorically encoded representations. In 1540 he was appointed deacon of the Lukas Guild in Haarlem and was granted tax exemption in 1572 on account of his artistic achievements. After his period in Rome, Michelangelo's influence made itself felt in Heemskerck's three-dimensional modelling of figures. His coloration was often cool and his painting technique smooth, to suit the wooden panel rather than the canvas.

This painting of an unknown family is one of the most important works of portraiture in 16th-century Netherlandish art. It also provides an exemplary illustration of the possibilities offered by the combination of Early Netherlandish tradition, Italian influences and creative talent. The clear compositional structure, stabilized by its "corner posts" of father and mother yet with no sense of rigidity, reflects both the influences with which Heemskerck was confronted in Rome and his own endeavours to lend plastic conviction to his figures and objects. The richly decked table, on the other hand, with its carefully executed tableware and food, takes up the love of detail so characteristic of Early Netherlandish painting. It is but a short step from here to the emergence of the still life as a genre in its own right.

While the different ages of the three children are accurately characterized, the figures nevertheless remain coolly distanced from the spectator. The inner world of the painting remains hermetically sealed, an impression reinforced by the technique employed for the background, whereby the paint is applied in thin, smooth layers in pale forms which seem to be abstracted from clouds. Heemskerck's *Family Portrait*, one of his greatest works, was for a long time attributed to his fellow Dutchman Jan van Scorel.

Portrait of a Woman at a Spinning-Wheel,
c. 1531

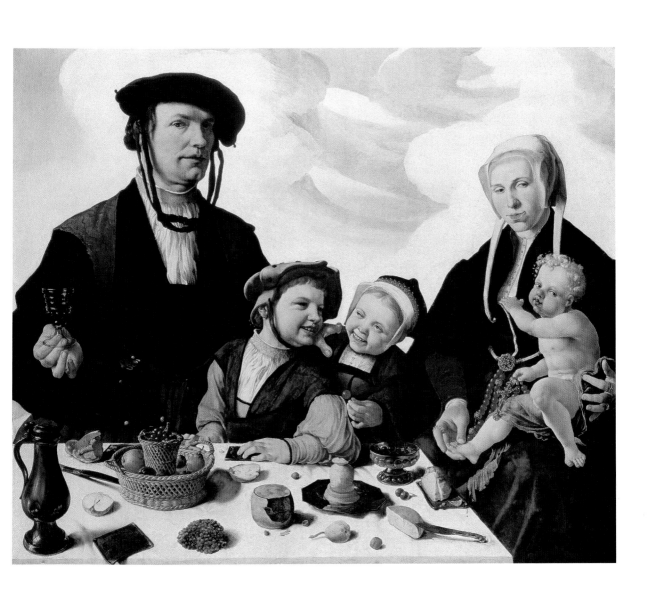

Leda and the swan

Oil on canvas, 152 x 191 cm
Berlin, Gemäldegalerie, Staatliche Museen zu Berlin – Preussischer Kulturbesitz

* c. 1489 Correggio (near Modena)
† 1534 Correggio

After his training, probably in Bologna and Ferrara, Correggio developed his own style based on Leonardo and 16th-century Venetian painting. His innovations were of the utmost importance to European art. He developed new ways of handling light and colour, creating the illusion of open walls and ceilings. Stimulated by the treatment of light by Mantegna (Camera degli Sposi in Mantua, Palazzo Ducale) and Leonardo (Sala delle Asse, Milan, Castello Sforcesco), Correggio opened up the refectory ceiling in the Convento di San Paolo in Parma (1518/19) purely by using his new painterly devices. The cupola frescos in San Giovanni Evangelista (*Christ Ascending to Heaven*, 1521–1523) and in Parma Cathedral (*Ascension of Christ in Glory*, 1526–1530), show that he did away completely with the upper margin so that his frescos cover the entire cupola. In his altar pieces and mythological scenes Correggio increasingly abandoned outline, using colour and light to balance forms and in this way achieving an overwhelming radiance. The High Renaissance structure, whose principle was founded on the antithesis of statics and dynamics, was transformed by Correggio to asymmetry and movement, as shown by his foreshortened figures whose posture is often complicated (*Madonna and St Sebastian*, Dresden, Gemäldegallerie, c. 1525; *Madonna and St Jerome,* Parma, Galleria Nazionale, c. 1527). Correggio's treatment of light and shade (*The Nativity*, Dresden, Gemäldegalerie, c. 1530; *Zeus and Io*, Vienna, Kunsthistorisches Museum) was to point far into the future.

Correggio's portrayal of Leda, receiving Zeus in the shape of a swan, demands direct comparison with Michelangelo's versions of the same subject, which survive only in copies. While Michelangelo concentrates exclusively on the figural group, Correggio sets the scene in a wooded landscape and embellishes it with bathing nymphs, Cupid playing his harp, and putti.

By presenting Leda in a complex, twisting pose from the front, the artist grants the spectator the clearest possible view of her union with the swan, yet without approaching obscenity. The accompanying figures – some bathing, others holding their clothes, others again making music – play an important role in this regard. Above all, however, it is the landscape which, painted in the most delicate sfumato, lends the scene a thoroughly idyllic character.

The composition, which at first sight appears entirely improvised with its unrestrained sense of movement and free distribution of figures, is in fact carefully crafted. Leda is accentuated by the large tree trunk behind, slightly offset to the left of the central axis. Nymphs, Cupid and putti are arranged in a semicircle around the central group of trees and thereby lead the eye into the depths of the landscape, which is itself treated with a high degree of freedom in its renunciation of emphatic detail.

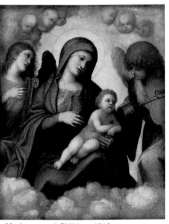

Madonna and Child, c. 1510

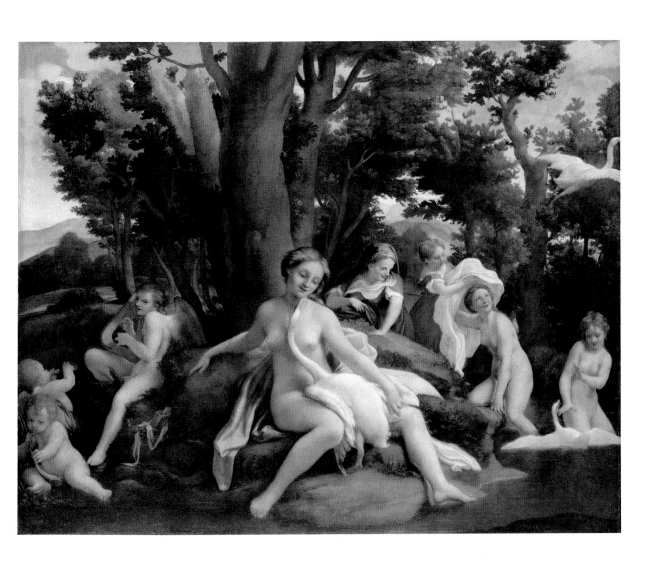

The Ambassadors

Tempera on wood, 207 x 209.5 cm
London, National Gallery

* 1497/98 Augsburg
† 1543 London

Amongst the great German masters of the 16th century Holbein may be singled out without reservation as the only Renaissance artist. Unlike any other he was, both in education and career, a cosmopolitan. At the early age of sixteen, after instruction by his father, he went off as a journeyman with his brother Ambrosius. He is first mentioned in 1515 in Basle, where he entered the workshop of Hans Herbster. His first public commissions were carried out in Lucerne in 1517. From there he probably visited Lombardy and Emilia in northern Italy. This is not supported by documentary evidence, but it is reflected in his work of the early 1520s. In 1519 Holbein became a member of the painters' guild in Basle, and in 1524 he stayed in France. The watershed of his career was his journey to England in 1526, where he went by way of the Netherlands, equipped with a letter of recommendation from Erasmus of Rotterdam. There he lived from 1532, despite tempting offers from the city of Basle. Between 1515 and 1528 he carried out a number of outstanding religious commissions (*Madonna of Solothurn*, Solothurn, Städtisches Museum, 1522; *The Dead Christ in the Tomb*, Basle, Kunstmuseum, 1521). In the Basle painting one can see in his powerfully expressive depiction of Christ a parallel to Grünewald, which Holbein succeeded in combining with razor-sharp observation, which showed his genius for portraiture. From 1528 he indeed concentrated solely on portrait painting. In London he executed portraits of the German merchants of the Steelyard, then soon came to the notice of Henry VIII and members of his court. His observation of detail, psychological penetration of his sitters and superb handling of colour made him the greatest portrait painter of German art. He also produced excellent graphic work (e.g. the series of woodcuts *Dance of Death*, completed about 1526; 91 woodcut designs on the Old Testament, completed 1538).

This panel was probably painted in April 1533, while bishop Georges de Selve (right) was in London visiting his friend Jean de Dinteville, French ambassador to England.

The square format which Holbein chose for his painting was one popular in the High Renaissance. Here it forms the starting-point for a carefully structured composition. The two men assume a framing function within the picture. Right and left, top and bottom are linked by means of verticals and horizontals, whereby the few diagonals present introduce a certain element of relaxation. The objects on the shelf and table incorporate themselves into this overall structure, each charged with a specific symbolism which in some cases has yet to be understood. There is clear preference for objects from the world of geometry and astrology. The broken mandolin string is a reference to death, as is the diagonal anamorphic figure in the foreground: a detail in distorted perspective, unintelligible when viewed frontally; however viewed from the bottom left-hand corner, it ist revealed as a macabre death's-head. The open book shows an extract from Johann Walter's "Geystliche Gesänge" (Sacred Songs) published in Wittenberg in 1524 – an allusion to the mediating position which the two noblemen occupied between Catholicism and Protestantism.

> **"Holbein imitated the colours of natural objects very faithfully. He is more tender in his tints than Dürer, he is more skilful in his brushwork, and his certainty rarely generates into harshness."**
>
> Johann Wolfgang von Goethe

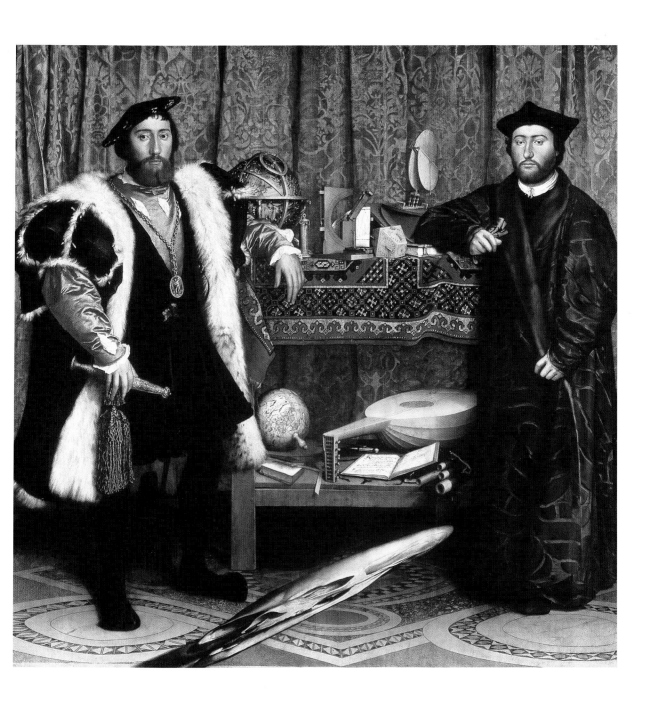

madonna of the Long Neck

Oil on wood, 219 x 135 cm
Florence, Galleria degli Uffizi

* 1503 Parma
† 1540 Casalmaggiore (near Parma)

In following the style of Correggio, Parmigianino also became his most significant successor in 16th-century painting in the Emilia region. His *Self-Portrait before a Convex Mirror* (Vienna, Kunsthistorisches Museum, 1523), which was to recommend him to the Pope, already shows him at the height of his art. The wealth of imagination and delicacy of approach shown in this work already hint at the dissolution of the ideal of High Renaissance portraiture. During his visit to Rome from 1524 to 1527 he was particularly impressed by Raphael and Giulio Romano. This did not, however, cause him to abandon his Mannerist tendencies. On his return to Emilia he worked predominantly in Parma and surroundings, carrying out many notable religious works and portraits. He also executed several frescos, and in this field he contributed greatly in removing the division between painting and sculpture (Scenes from the story of *Diana and Actaeon*, Fontanellato, Kastell, c. 1523; *Virgins carrying Urns*, Parma, Santa Maria della Steccata, between 1531 and 1539). Parmigianino was influential both in his native region and in Venice.

This panel, whose right-hand side remains incomplete, represents one of the most important examples of the anti-High Renaissance tendencies which have become known as Mannerism. The very subject itself remains ultimately undecided between a Virgin and Child enthroned and a Pietà.

The complicated, in places almost affected movements of the figures are combined with the anatomical distortions to which the painting owes its title. The Madonna's robes have a decorative value independent of the structure of her body. In the absence of any solid throne, she appears half-way between sitting and floating.

The sense of "alienation" introduced by the anatomy of the figures is echoed in the illogical composition of space. Just as the precise locality of the foreground angels is itself unclear, so the eye is utterly confused by the discrepancies in scale between the main foreground group, the small figure of the prophet announcing the coming of Christ on the right-hand edge of the panel, and the (unfinished) columns towering behind.

It would be wrong, however, to see Parmigianino's deviation from the norms of the High Renaissance as purely formal in nature; rather, he is here exploring a new means of rendering visible a dimension beyond that of earthly reality.

Madonna with Child and Saints, c. 1530

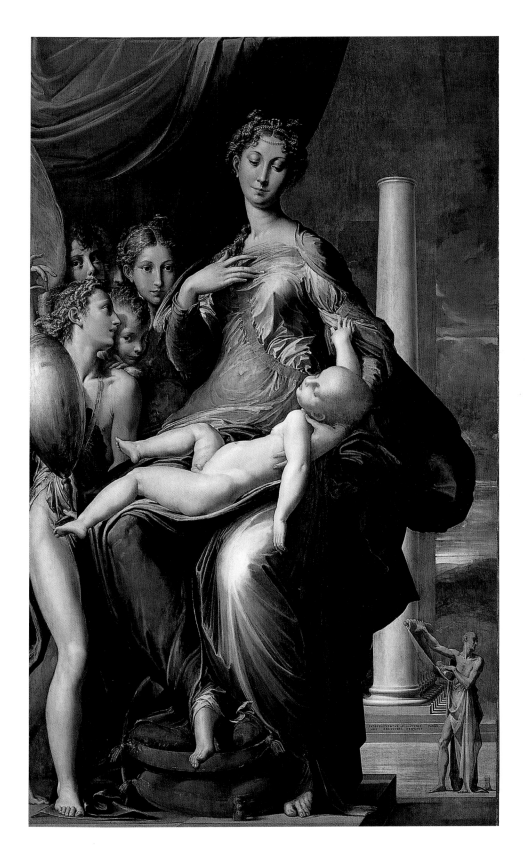

An Allegory (venus, cupid, Time and Folly)

Oil on wood, 146 x 116 cm
London, National Gallery

* 1503 Monticelli (near Florence)
† 1572 Florence

After an apprenticeship with Raffaelino del Garbo, the young Bronzino assisted Pontormo in 1522 with the frescos in the Certosa di Galuzzo near Florence, where he received decisive artistic impulses for his future. But he moved increasingly away from Pontormo's spiritual tendencies, favouring a highly refined, detached aestheticism. In 1539 he participated in the decorations for the wedding of Cosimo I de' Medici with Eleonora of Toledo and won such favour that he became their court painter and portraitist. His portraits, usually painted in cool colours and in which the figures are placed silhouette-like before the background, are the most refined of their kind in the 16th century. During his visit to Rome from 1546 to 1548 Bronzino studied in particular the works of Raphael and Michelangelo, from whose novel ways of portraying the figure he benefited, as is apparent in such works as the fresco *Martyrdom of St Lawrence* (Florence, 1565–1569). In his later work he developed under the influence of what were then the latest theories seeking to unlock the code of allegorical representation. In these works he manages to balance cool sensuality with an elaborate composition. The colour surface often attains an enamelled smoothness.

Agnolo Bronzino here portrays an elaborate allegory of the pleasures and pains of love. In the foreground, the spiralling figure of Cupid embraces Venus, whose upright figure is turned frontally towards the spectator. A boy arriving from the right is scattering roses. In the background, meanwhile, we can identify the figures of Old Age,

Jealousy and Deceit. The composition is almost stilted in its artificiality: Venus' arms and legs run parallel to the edges of the panel, while the background assumes the staggered character of a relief. The anatomically elongated arm of the old man completes the figuration, which calls to mind Theodor Hetzer's concept of "pictorial ornament".

The palette, too, is artificial. Bronzino creates a smooth, enamel-like surface, for which his choice of a wood panel is clearly more suitable than canvas. In its cool eroticism, the painting bears witness to a specifically French style of court art whose roots go back to Jean Fouquet and the 15th century. As court painter to the Medici, Bronzino executed large numbers of portraits characterized by a formal severity, a minute attention to detail and a cool sophistication.

Since Bronzino painted the present panel for King Francis I of France, it must have been executed before 1545.

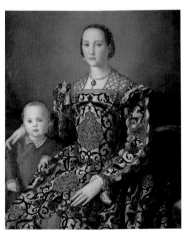

Eleonora of Toledo and her Son Giovanni,
c. 1545

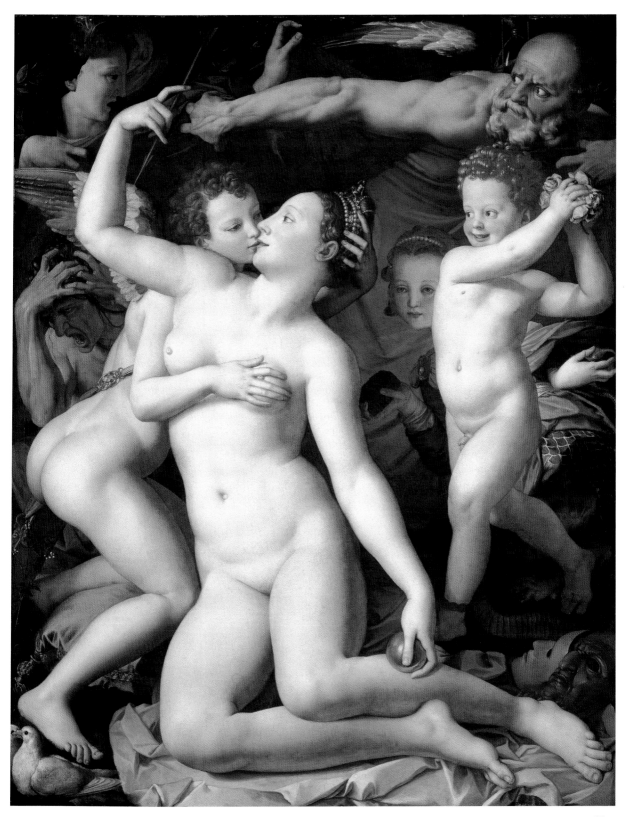

Diana the Huntress

Oil on wood, transferred to canvas, 191 x 132 cm
Paris, Musée National du Louvre

This name is given to the group of artists, predominantly from Italy, who were involved in the decoration of the palace of Fontainebleau, begun in 1528 under Francis I. They brought Mannerist style elements to France and contributed greatly to their introduction north of the Alps. With the arrival of Rosso Fiorentino in 1530, Primaticcio in 1531, and Niccolò dell'Abbate in 1552, Fontainebleau became the centre of exchange between Italian and French art. Notable works combining various artistic branches are the galleries of Francis I (Rosso) and Henry II (Primaticcio).

During the so-called second School of Fontainebleau (from 1590) a decorative style was developed under the leadership of the Antwerp artist Ambroise Dubois and two French painters, Toussaint Debreuil and Martin Fréminet, which through printed copies became widely distributed all over Europe. It is not always possible to determine the relative degree to which Italian, French and Dutch masters contributed.

As with the *Landscape with Threshers* (c. 1555–1565, Musée National du Château, Fontainebleau), precisely who executed this painting remains unknown. The slender proportions of the figure, with its small head and its extremely complex pose, point to the influence of the first School of Fontainebleau surrounding Rosso Fiorentino and Primaticcio. While Diana is effectively seen in profile, walking from right to left, this side view is skilfully manipulated. Thus the slight twist of her shoulders in the opposite direction to her step allows us to see her spine, while her head is turned in the opposite direction to her shoulders.

Typically Mannerist is the contrasting intensity of the movements made by Diana and the dog beside her. In the juxtaposition of the goddess's slow step and the bounding hound, two different rhythms are captured in the same instant.

The group of trees in the background and the view of the landscape are executed in the same generous, sweeping style as the *Landscape with Threshers* – a distinctive feature of the second School of Fontainebleau and something which would form one of the foundations of the French landscape painting of the 17th century.

The delicate, cool eroticism evident in *Diana the Huntress* is characteristic of many of the works by the School of Fontainebleau and was fully in line with French tastes of the day.

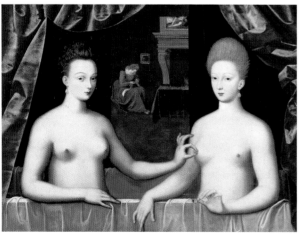
Gabrielle d'Estrées and One of her Sisters in the Bath, c. 1594–1599

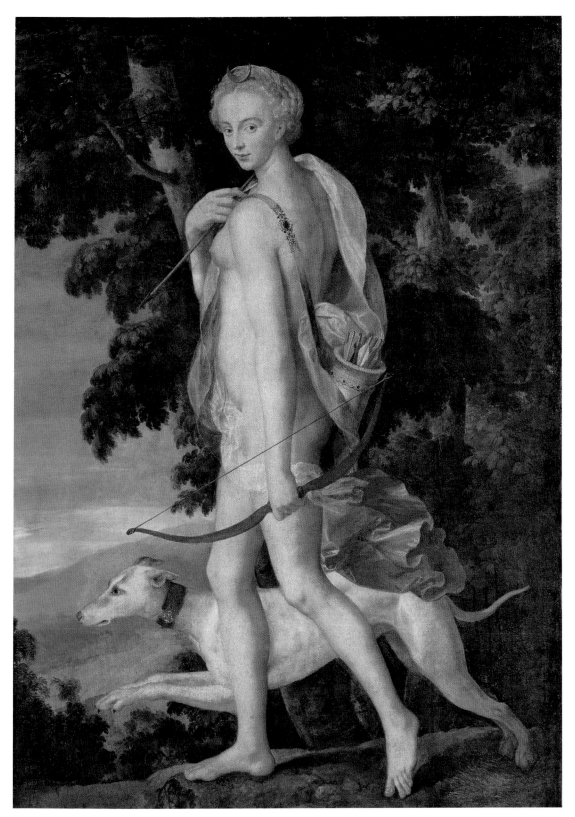

vulcan surprises venus and mars

Oil on canvas, 135 x 198 cm
Munich, Bayerische Staatsgemäldesammlungen, Alte Pinakothek

* 1519 Venice
† 1594 Venice

In the great triad of 16th-century Venetian art, Tintoretto upheld Mannerist principles more rigorously than either Titian or Veronese. Jacopo Robusti, called Il Tintoretto because his father was a dyer by trade, was trained in the workshop of Titian. He was first mentioned as master in 1539. Between 1548 and 1563 he painted several large-scale pictures of the *Miracle of St Mark*. They stand out in their vehement dynamism achieved by bold foreshortening and exaggerated gestures. This was new in Venetian painting, as was the plastic modelling of the forms which went beyond Michelangelo's inventions. Also, the overall unity of the composition was disturbed by flickering light.

It is not known whether Tintoretto ever went to Rome, but he is said to have made studies of copies of Michelangelo's and Giambologna's paintings and of ancient art, even for his later works, when light became the determinant factor in his art. According to Marco Boschini, Tintoretto used to set up a scene with small wax figures equivalent to the painting he had in mind, and then experimented with light sources. From 1564 to 1587 he was engaged in the decoration of the Scuola di San Rocco; the comprehensive scope of this work demonstrates the quality and range of his talents. Alongside works of the highest order stood those in which the virtuoso effect gained the upper hand. But it has to be taken into account that Tintoretto had a large workshop and inexhaustible energy which made any commission welcome.

In the painting of the 16th century, the relationship between Venus and Mars — portrayed by Botticelli in idealized, neo-Platonic terms — assumed a strongly erotic flavour. It is typical of Tintoretto, with his preference for drama, that he should choose to portray the moment not of the lovers' union, but of their discovery by Vulcan, Venus' ageing husband. Vulcan, still in mid-step, lays bare Venus' sex, while Mars hides under the bed.

The room recedes at an angle from front left to rear right. Its pronounced asymmetry is established by the foreshortened wall on the left, reinforced in the figure of Cupid, and by the tiles leading into the neighbouring chamber beyond. A similar extension of space is suggested by the mirror, which simultaneously aligns itself with the main figures into another diagonal. The mirror also serves a second important function: it transforms the figure of Vulcan, already rendered substantial by his animated pose, into a "sculpture" visible from all sides at once — an impression further reinforced by his muscular modelling, based on studies by Michelangelo. The nude Venus, probably inspired by Titian's "Andromeda", appears almost boyishly demure by contrast. Venus provides the compositional counterweight to the powerful diagonal recession into the depths.

The Berlin Kupferstichkabinett houses a preliminary study for this painting in the shape of an ink drawing of great spontaneity, unique in Tintoretto's œuvre in its technique and its exploration of the background. The figures of the reclining Venus and of Mars under the bed are missing, however.

"Beautiful colours can be bought in the shops on the Rialto, but good drawing can only be bought from the casket of the artist's talent with patient study and nights without sleep."

Tintoretto

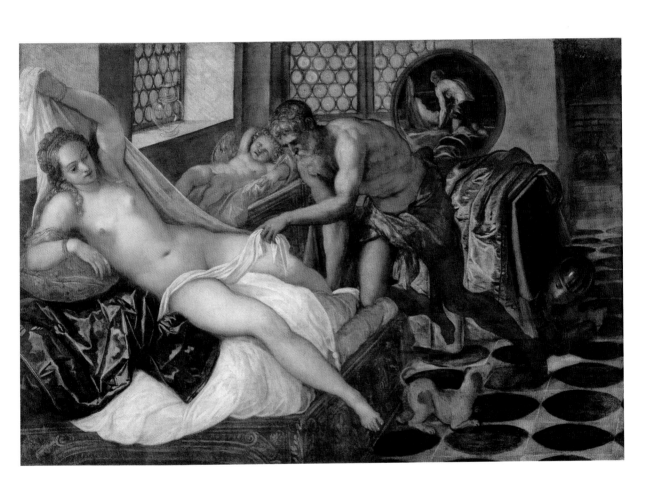

The Hunters in the snow (the month of January from the cycle "paintings of the months")

Oil on wood, 117 x 162 cm
Vienna, Kunsthistorisches Museum

* c. 1525–1530 Breda (?)
† 1569 Brussels

His nickname "Peasant Brueghel" harks back to his depiction of peasant life, proverb and genre scenes, unduly diminishing the importance of this great Netherlandish painter of the 16th century. In his representations of the life of peasants and the underprivileged, Brueghel penetrated the outer shell, converting them to images applicable to human life in general, such as in the folly of the World (*Country of the Blind*, Naples, Museo Nazionale di Capodimonte), the transience of material values (*The Land of Cockaigne*, Munich, Alte Pinakothek), or the fate awaiting the power-greedy (various versions of the *Tower of Babel*). In some respects Brueghel takes up the concerns of Bosch. He undoubtedly belongs to the phase of European Mannerism in breaking up the composition into small parts (Proverb pictures, Berlin, Gemäldegalerie), or the suggestion of movement (*Country of the Blind*).

On the other hand, with his later works which show a new overall unity of structure and also greater use of large figures, he paves the way for the Baroque north of the Alps. His visit to Italy in the 1550s, which took him to the far South, might have contributed to this change. His significant place as a landscape painter in the whole of European art in the 16th century is undisputed. In the *Months* pictures created around 1565, colour developed into an elemental force, pointing far into the 17th century.

As in the other *Paintings of the Months*, the main subject of the present panel is the landscape, with the scenic elements – the hunters setting off with their pack of hounds, the skaters – simply providing supplementary details. Even without any figures in the picture at all, the spectator would associate the snow-covered fields and mountains, frozen stretches of water and bare trees with winter.

With the same technique that he uses elsewhere to portray sunlight, Brueghel here evokes the overwhelming impression of frost. The landscape unfolds in a similar fashion to that of *The Corn Harvest*: from an elevated foreground, the eye is led over an abrupt drop and across lower-lying fields to the hills rising in the background. Not until the Baroque era would landscape be continuously developed from the front edge of the picture rearwards in a smooth fusion of foreground, middle ground and background. A grid of vertical and diagonally descending and ascending lines provides the composition with a stable basic framework. The dominant axis is the emphatic diagonal leading from the pack of hounds bottom left to the mountain range top right. In a masterly demonstration of Brueghel's feeling for pictorial space, the landscape – which, for all its detail, seems empty – is lent depth by the bird in mid-flight.

"painters who paint gracious creatures in the bloom of youth and who wish to graft on to the sitter some further element of charm or elegance from their own imagination disfigure the whole creature whom they have painted; they are not faithful to their model and thus they distance themselves in the same measure from true beauty. our Brueghel is free of this fault."

Abraham Ortelius

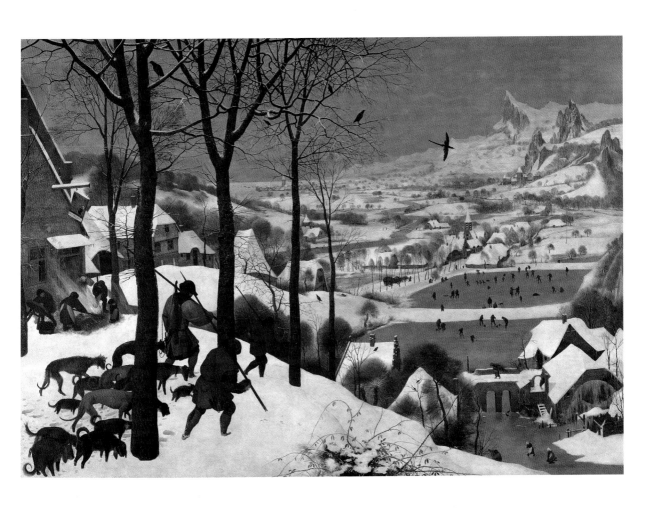

Lady in her Bath (Diane de Poitiers?)

Oil on wood, 92 x 81 cm
Washington, National Gallery of Art

* c. 1505–1510 Tours (?)
† 1572 Paris

François Clouet was trained by his father Jean Clouet, but little is known of the life of either of them. François went to the French court at an early age, and on the death of his father about 1540 was granted a salary by Francis I. His successor Henry II appointed Clouet valet de chambre and painter-in-ordinary. Contemporary documents give evidence of his high reputation. Only two pictures of importance remain: the *Portrait of Apothecary Pierre Quthe* (Paris, Louvre, 1562) and the *Lady in her Bath*. Both works prove Clouet's involvement with the Italian Renaissance, in particular with Leonardo's Lombardic successors. The painter may also have had contacts with the School of Fontainebleau.

In seeking to establish a tension between erotic appeal and cool distance, Clouet clearly reflects the influence of Italian painters such as Bronzino. The almost square format becomes the starting-point for an emphatically asymmetrical composition, in which the main figure is located in the front right-hand corner and further accentuated by a large gap in the red curtains. Just as a tension is thereby created between pictorial format and composition, so the same tension arises between plane and space. The beautiful woman in the foreground turns towards the viewer in such a way that her lower and upper arms repeat the horizontal and vertical sides of the frame. The outlines of the curtains further serve to bind the composition to the plane. In diametric opposition to this, however, the eye is drawn almost forcefully into the depths on the left, whereby the distance suggested by the smaller scale of the seated woman in the background is not supported by the perspective construction. Contradiction is also the keynote of the palette, as seen in the brightly lit nude set against a shadowy ground. Although lagging behind his father Jean in terms of technique, François Clouet surpassed him in artistic invention. Diane de Poitiers, the mistress of Henry II, probably provided the model for the bathing woman.

"Cleopatra, Johanna of Naples, Diane de Poitiers, Mademoiselle de La Vallière, Madame de Pompadour, in short, most of the women who have been made famous by love, had no lack of imperfections or physical faults, while most of the women whose beauty is represented to us as perfect saw their love-lives end unhappily."

Honoré de Balzac

Portrait of Elisabeth of Austria, Queen of France, c. 1535

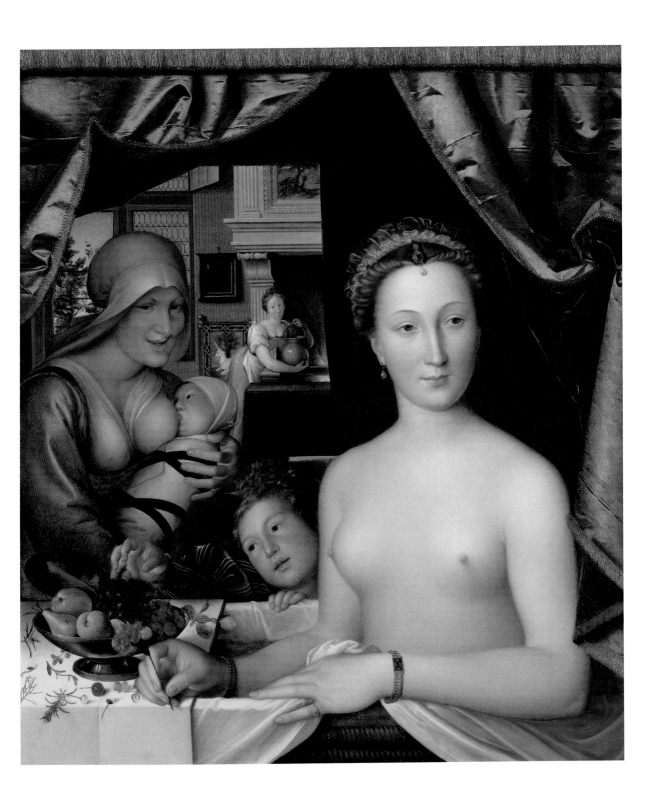

The Finding of Moses

Oil on canvas, 50 x 43 cm
Madrid, Museo del Prado

* 1528 Verona
† 1588 Venice

Veronese studied under Antonio Badile in Verona from 1541, but his true masters were the Venetian painters Titian and Tintoretto as well the painters of the Emilia region, including Parmigianino. In 1553 he went to Venice, where he was called Veronese after his place of birth. Veronese was the opposite of Tintoretto: while the latter moved into Mannerism, Veronese's art was securely rooted in the Italian High Renaissance. His works not only reflect the religious and political unrest of his time, but also the love of pomp and worldly splendour of Venetian life. In so far as content often seems to have been subordinated to form in his works, he was also a typical representative of 16th-century art. This is why three centuries later Cézanne saw him as the precursor of pure form. His first large commission was the decoration of the sacristy and ceiling in San Sebastiano, Venice, in 1555/56. For this he executed a great many pictures on canvas with bold perspective views and foreshortening of figures. During a visit to Rome in 1560 he studied in particular Michelangelo's work in the Sistine Chapel. In subsequent works the impressions he received there found application in the plastic modelling of figures in movement and the further development of illusionistic spatial depth. A major example of this period are his frescos in the Villa Barbaro in Maser executed in the early 1560s. Veronese's influence reached far beyond his time. The virtuosity of his composition not only played an important part in the works of Rubens and Tiepolo, but also had many followers amongst the European painters of the Baroque; and his handling of colour remained of importance in French art until the 19th century.

Rarely has *The Finding of Moses* received such a festive treatment as here. In growing fear of the constantly increasing numbers of Israelites, the Pharaoh ordered all new-born sons to be put to death – the Old Testament counterpart to the slaying of the infants of Bethlehem by Herod. Moses' mother hid her baby in a bulrush cradle amongst the reeds of the Nile, where he was found by the Pharaoh's daughter and adopted as her own child. The composition combines movement of the most natural and unselfconscious kind with the ordered arrangement established by the harmonious relationship between the figures and the landscape. Particularly important in this respect are the two foreground trees, whose diverging V-shape echoes the poses of the main figures. In the delicate luminosity and subtle gradations of its rich palette, the painting occupies a unique position in Veronese's œuvre and seems to look forward to Velázquez.

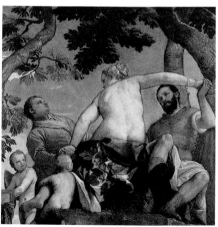

Allegory of Love: Unfaithfulness, c. 1575–1580

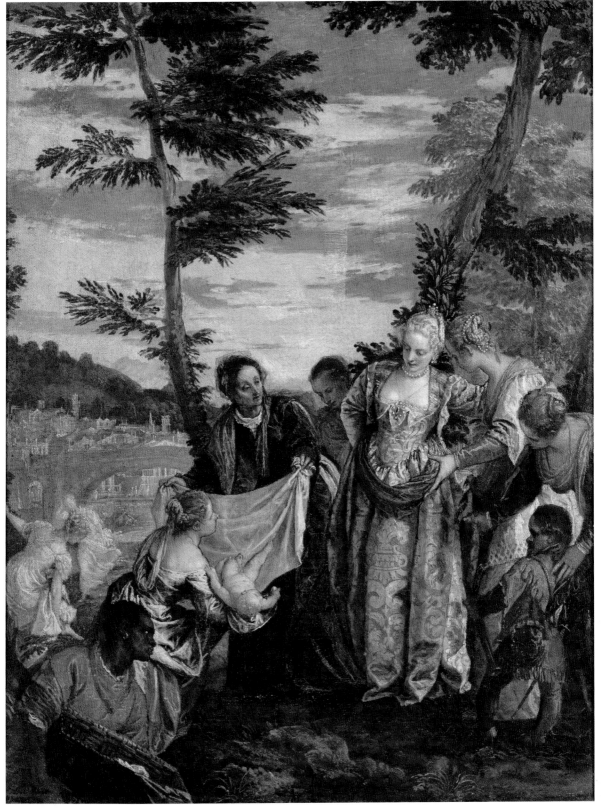

тhe вurial of count orgaz

Oil on canvas, 480 x 360 cm
Toledo, Santo Tomé

*** c. 1541 Phodele (Crete)**
† 1614 Toledo

As a most unusual phenomenon in 16th-century European painting, El Greco combined the strict Byzantine style of his homeland with influences received during his studies in Venice and the medieval tradition of his country of adoption, Spain. El Greco obtained his training as icon-maker in a monastery. He then went to Venice where Titian became his greatest mentor. In Titian's workshop he developed the brilliance of colour which became a lasting element in his entire work. But he was also moulded by Tintoretto's Mannerist style, as is shown in his delight in bold perspectival foreshortening, the complicated movements of figures and groups of figures, the elongation of proportions and his strong chiaroscuro. In 1570 El Greco went by way of Parma to Rome, where he met Michelangelo. He criticised his *Last Judgement* severely, offering to produce a better composition. This attitude is a particularly telling example of historical irony. The only painter of the very highest order to come from the land where the art of classical antiquity was born failed to understand the High Renaissance ideal of bodily beauty.

El Greco's acquaintance with Spanish humanists in Rome and the expectation of commissions in connection with the rebuilding of the monastery of El Escorial might have been what led him to migrate to Spain in 1577. At first he was in the service of Philip II (*Dream of Philip II*, El Escorial, 1580), then settled in Toledo in 1580 where he received a great number of church commissions and also became a popular portraitist. Historical records tell us of many disputes with commissioners about inappropriate interpretation of religious themes,

unusual coloration, elongation of figures, but also old-fashioned representation. In the course of his development El Greco became gradually detached from the reality of representation. He distorted the human figure, abandoned logical space construction and also used colour no longer objectively. It is possible that his Byzantine legacy may have been responsible for his growing asceticism. For a long time almost forgotten, interest in him revived in the early 20th century on account of his tendency towards the abstract and his depiction of dream-like scenes. He is now considered as one of the most important representatives of European Mannerism.

The inscription beneath this altarpiece describes the legendary events taking place. During the burial of the devout Count Orgaz in the first half of the 13th century, St Stephen and St Augustine are supposed to have come down from Heaven and placed the body in the tomb themselves. El Greco paints a fascinating vision in which the earthly and heavenly worlds are both contrasted and at the same time unified. Surrounded by clergy and nobles, the two saints lower the body into the grave. A boy in the left-hand foreground – El Greco's son? – looks out at the spectator and points to the events taking place. All spatial depth and background detail is renounced. This enables the heavens to open directly overhead, revealing Christ seated in judgement with Mary and John the Baptist as intercessors for humanity. The upward train of movement indicated in the celestial sphere complements the lowering movement of the main group on the ground: death and resurrection are simultaneously portrayed.

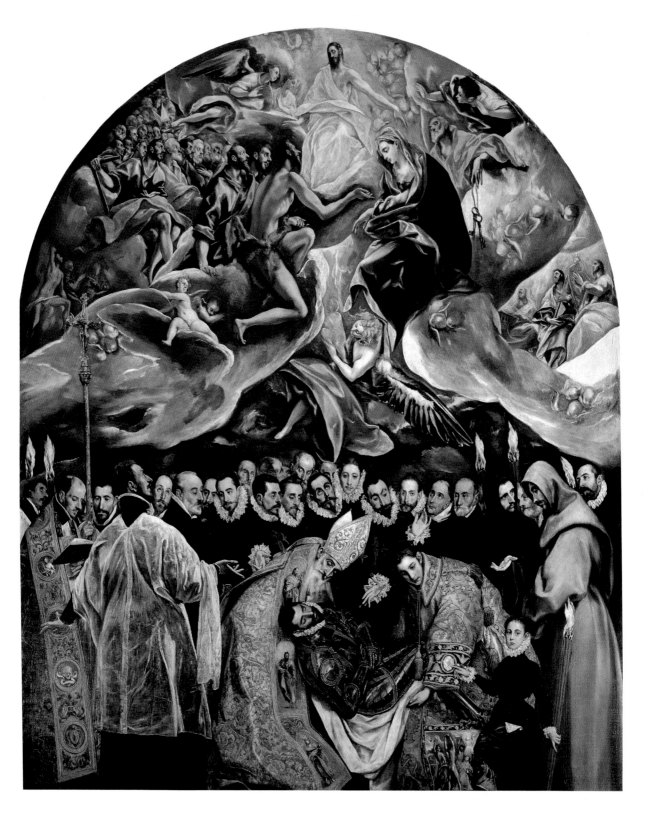

To stay informed about upcoming TASCHEN titles, please request our magazine at www.taschen.com/magazine or write to TASCHEN America, 6671 Sunset Boulevard, Suite 1508, USA-Los Angeles, CA 90028, contact-us@taschen.com, Fax: +1-323-463.4442. We will be happy to send you a free copy of our magazine which is filled with information about all of our books.

© **2006 TASCHEN GmbH**
Hohenzollernring 53, D–50672 Köln
www.taschen.com

Project management: Juliane Steinbrecher, Cologne
Editing: Stilistico, Cologne
Translation: Karen Williams, Rennes-le-Château
Design: Sense/Net, Andy Disl and Birgit Reber, Cologne, and Tanja da Silva, Cologne
Production: Martina Ciborowius, Cologne

Printed in Germany
ISBN 10: 3-8228-5296-1
ISBN 13: 978-3-8228-5296-5

Page 1
RAPHAEL

Madonna della Sedia
c. 1513/14, Oil on wood, diameter 71 cm
Florence, Galleria Palatina

Page 2
LEONARDO DA VINCI

Portrait of Cecilia Gallerani
(The Lady with the Ermine)
1489/90, Oil on wood, 55 x 40.5 cm
Cracow, Muzeum Narodowe, Czartoryski Collection

Page 4
MICHELANGELO

Last Judgement
1536–1541, Fresco, 1375 x 1220 cm
Rome, Vatican, Sistine Chapel